Go *Wild* with Quilts~ *Again!*

That
Patchwork
Place®

Margaret Rolfe

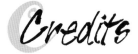

Credits

Managing Editor . Greg Sharp
Technical Editors Kerry I. Hoffman
 Sharon Rose
Copy Editors . Liz McGehee
 Miriam Bulmer
Proofreader Kathleen Pike Timko
Technical Illustrator Carolyn Kraft
Illustration Assistant Lisa McKenney
Wildlife Illustrator Phil Rolfe
Photographer . Mike Fisher
Design Director . Judy Petry
Cover Designer David Chrisman
Text Designer Joanne Lauterjung
Design Assistant Dani Ritchardson

Go Wild with Quilts—Again!
© 1995 by Margaret Rolfe
That Patchwork Place, Inc., PO Box 118,
Bothell, WA 98041-0118 USA

Printed in Hong Kong
00 99 98 97 96 6 5 4 3 2

Library of Congress Cataloging-in-Publication Data
Rolfe, Margaret.
 Go wild with quilts—again! / Margaret Rolfe
 p. cm.
 ISBN 1-56477-126-1
 1. Patchwork—Patterns. 2. Patchwork quilts.
3. Decoration and ornament—Animal forms. 4. Birds in art. I. Title.
TT835.R65123 1995
746.46—dc20 95-35894
 CIP

Acknowledgments

An author alone does not create a book. My sincere thanks to all at That Patchwork Place who share my commitment to excellence in quilting books and who put the time and care into creating a quality book. Thank you to Beth Miller, Beth and Trevor Reid, and Judy Turner, who helped me with their fine quilting. For help with timely advice, constructive criticism, and design testing, I am grateful to Donna Sunderland, Barbara Goddard, and Kerry Gavin. Thanks to Frances Arnold, for her recommendation of freezer-paper piecing, and Val Nadin, for her suggestion of foundation piecing. Karen Hamrick generously loaned her Turtle block for photography. I owe a special debt to Nancy Cameron Armstrong for her encouragement and generous sharing of resources on North American wildlife.

My son Phil, who draws the animals and birds so beautifully, has contributed enormously to this book. I very much appreciate the addition of his wonderful talent to my work. Thanks also to my son Bernie and my daughter, Melinda, for all their help. Above all, my heartfelt gratitude to my husband, Barry, who continues to support, encourage, and help me in every conceivable way. None of this would be possible without him.

DEDICATION

This book is dedicated to my three children, Bernie, Phil, and Melinda. I hope that when they inherit the world, it will still be a beautiful place full of wild creatures.

MISSION STATEMENT

WE ARE DEDICATED TO PROVIDING QUALITY PRODUCTS THAT ENCOURAGE CREATIVITY AND PROMOTE SELF-ESTEEM IN OUR CUSTOMERS AND OUR EMPLOYEES.

WE STRIVE TO MAKE A DIFFERENCE IN THE LIVES WE TOUCH.

That Patchwork Place is an employee-owned, financially secure company.

Contents

Introduction

It is with much pleasure that I bring you another set of pieced animal designs in this sequel to my book *Go Wild with Quilts*. There are just so many wonderful possibilities for quilts with wildlife as the theme!

In addition to my basic "straight-line patchwork" method, this book introduces three new techniques. For those of you whose rotary cutter is like an extension of your arm, I have worked out a way to cut out the animal blocks using this tool. I also included the option of using freezer paper. Foundation piecing is currently enjoying great popularity. I adapted two of the bird designs to create miniature blocks that can be foundation pieced.

This book, like the first, grew out of my love of animals and birds. Man, the dominant mammal, shares the world with a host of other creatures, whose beauty and variety we do not always appreciate. At times, our needs and theirs are incompatible, and adjustments have to be made. But, all too often, our destruction of nature has been just selfishness and thoughtlessness. We do not appreciate what we have until it is too late.

I believe we live in a beautiful world, which we should enjoy and appreciate. My quilts celebrate that beauty. Mother Nature is the greatest pattern maker of them all!

I hope that you will enjoy these new block designs and the quilts I have created for them. Above all, I hope that you will make these creatures your own and use them creatively in your own quilts. Please do go wild with quilts—again!

Margaret Rolfe

Materials and Equipment

Fabric

If possible, choose all-cotton fabric for your piecing and appliqué. Cotton is best because it is easy to work with, and it can be sewn and pressed beautifully. Do not be bound by this, however; if the fabric you *need* is only available in a blend or man-made fiber, go ahead and use it. Be aware that it may be more difficult to handle.

I belong to the "wash it as you buy it" school of fabric care. I find that preshrinking is the best way to avoid nasty surprises.

Batting

Many types of batting are available today. They include cotton, polyester, wool, and blends and come in all different strengths and thicknesses. Choose the kind you find easiest to work with. Thinner battings work best for machine quilting as there is less bulk to fit under the machine.

Thread

For piecing and appliqué, choose dressmaking or serging thread in a neutral or matching color.

For embroidery, use as many strands of embroidery floss as you need to achieve the desired thickness.

For hand quilting, choose quilting thread in either white or cream (the traditional choices) or another matching or contrasting color.

For machine quilting, choose either monofilament thread (clear for light fabrics, smoky for dark fabrics) or blending or contrasting dressmaking thread.

Template Material

Plastic templates are durable and easy to make and use. You can buy template plastic marked with a grid, which allows you to draw the block directly onto the plastic rather than tracing it.

Thin, stiff cardboard can also be used for templates. Glue the paper copy of the design onto the cardboard and cut it out.

Sewing Machine

A straight-stitch machine in good working order is suitable for piecing. A walking foot makes machine quilting easier, and a darning or other special foot is required for free-motion quilting.

Scissors

Keep several pairs handy: paper scissors for cardboard, paper, and template plastic; good-quality dressmaking scissors for fabric; and small, sharp, pointed scissors for embroidery and appliqué.

Rotary Cutter and Mat

A rotary cutter and mat are essential. The time and effort they save make them a worthwhile investment. I recommend the medium-size cutter (2" blade) and a mat that measures at least 18" x 24".

Rulers

Along with your rotary cutter and mat, you need a selection of quilter's rulers. A 6" x 24" ruler for cutting long strips and a Bias Square® for cutting small squares are essential. A 6" x 12" ruler for cutting small pieces and a 12½" square ruler for cutting large squares and triangles and squaring up blocks are also useful. Buy good-quality rulers; accuracy is important. Be sure your rulers have marks at ⅛" intervals, as you need these to measure ⅛" cuts for triangles.

Pins

Pins with glass or plastic heads are easy to use and easy to find when you drop them. I prefer regular-length pins to the long pins often suggested for quilting.

Use 1"-long safety pins to pin-baste the layers for machine quilting. I keep several hundred on hand.

Needles

For appliqué, embroidery, and any other hand stitching, use crewel needles. For hand quilting, use a "Between" needle. Choose a size that is comfortable and easily accommodates your thread.

Quilting Hoop or Frame

A quilting hoop or frame holds the quilt layers in place while you hand quilt. Choose a size that is comfortable for you and fits your work space.

Thimbles

Wear a thimble to prevent pricked fingers as you hand quilt. I use two—one on the middle finger of my right hand to push the needle and a second on the index finger of my left hand to protect it as it guides the needle back up through the layers. In addition to thimbles, which are available in various shapes and sizes, there are leather protectors, special tapes, and hand-held devices that guide the needle.

Layout Board

It is important to lay out the pieces of the animal blocks before you begin piecing to ensure that each piece is correctly oriented. Make a permanent layout board by gluing white felt to a 20" square of cardboard. You can also use this handy board to lay out the pieces of traditional blocks.

Sandpaper Board

Place a sheet of fine sandpaper under your fabric as you mark around a template. The sandpaper grips the fabric so that it does not slip, making marking more accurate. Glue the sandpaper to a thin piece of particle board or tape it to your work surface to keep it from sliding around.

Photocopier

A photocopier with an enlargement feature enables you to enlarge the block designs to any size.

Drawing Tools

You need pencils, an eraser, and a ruler to copy blocks. Colored pencils add color to the designs. To transfer designs onto template plastic, use a fine-tip permanent marking pen. Use a soft (#2) pencil to mark quilting designs on a quilt top.

Tape

You can use masking tape to mark simple quilting designs. Use transparent tape to repair plastic templates and to hold paper templates in place for rotary cutting (page 14).

Stickers

Red dot stickers are a handy way to indicate the right side of a template.

Chalk

Use chalk to mark designs for machine quilting. Several different colors are available, and the lines fade quickly, leaving a clean, finished quilt. A chalk wheel gives the finest lines.

Iron

Use an iron to press your fabric before cutting and to press each seam you sew. If possible, set up your ironing board next to your machine. Have a spray bottle handy to dampen any stubborn pieces.

Design Wall

It is ideal to have a large felt-covered wall or board to which you can stick or pin your blocks, especially when you are using many different fabrics and need to balance or arrange the colors. If you don't have a suitable wall space, pin a flannel sheet or a large piece of firm batting to curtains or a wall and take it down when not in use.

Choosing Colors and Fabrics

Choosing fabrics for your quilts is both the easiest and the hardest thing to do. Easy because there is such a variety of marvelous patterns and colors available—it is such fun to visit quilt and fabric shops and find so many beautiful and tempting pieces to buy. Hard because finding the perfect fabric, which is the secret of successful quiltmaking, can be a real challenge. When choosing fabrics, keep the following principles in mind.

* **Color and design are relative.** The important thing is how a fabric looks when combined with other fabrics. At times, an "ugly" fabric may be just what you need. There is no such thing as a truly ugly fabric—just a fabric in the wrong place or the wrong amount.

* **Keep value in mind.** Value is the lightness and darkness of the fabric. Patchwork patterns are often created through the contrast between light and dark rather than through color. The designs in this book are most successful when there is a "figure/ground" relationship. This means that the animal blocks look best when there is contrast between the animal (figure) and the background (ground). Choose a light background for a dark-colored animal or bird and vice versa. Remember, though, that lightness and darkness are relative—the value of each fabric is determined by its neighbors.

Choosing backgrounds for the animal blocks can be complicated by the range of values within the animal. The chickadee, for instance, has a black head, a gray/brown wing, a white patch behind the eye, and a creamy breast. The bird itself contains the whole dark-to-light spectrum from black to white. A medium background might work best here. Too light a

background and the bird's breast would disappear; too dark a background and its head would disappear. With a medium-value background, both the light and the dark of the bird stand out.

* **Use more fabrics rather than fewer.** As the saying goes, never use just one print if you can use twenty. A variety of fabrics creates interest, giving your eye more to look at and delight in. For example, if, instead of just one blue, you use lots of different blues, you actually increase the quality of blueness. When the fabric requirements call for "½ yard total assorted green prints," this is your invitation to use as many different fabrics as possible.

* **Always look for interesting fabrics**—prints that suggest unusual textures or have motifs to fit the theme of your quilt. For example, the border of the Loon quilt (page 53) is a leaf print, which fits the theme of the quilt. This fabric is also interesting in itself—it contains a variety of tonal values, and the large leaves form nice positive and negative shapes (the shapes of both the leaves and the background behind them). When I come across a fabric that has this kind of interest, I buy 1½ to 2 yards so I can use it for borders or backgrounds. A strong and wonderful fabric can make a quilt, as the great multicolored fabric in the Turtle quilt (page 73) illustrates.

* **Have fun.** Remember, you are creating a quilt, not an exact replica of an animal or bird! Feel free to use wild and unusual colors and even to alter the natural colors of the animal. The important thing is to make the fabrics in the quilt work together, rather than to be true to nature.

glue Pattern to Freezer Paper

Piecing the Blocks

Quilts in this book combine two types of blocks: straight-line patchwork animal blocks and traditional patchwork blocks used for settings and borders. Different methods are used for piecing these two kinds of blocks, so it is very important that you understand the differences and use the appropriate method for the block you are making.

STRAIGHT-LINE PATCHWORK

To take advantage of modern equipment and materials, choose one of the three approaches to straight-line patchwork offered below. The first is the traditional method, using templates. It is much like traditional hand piecing, only you may stitch the seams by machine. I suggest this tried-and-true approach if you are new to patchwork and quilting. The second is a rotary-cutting method for those who are comfortable and experienced with rotary cutters. The third method is freezer-paper piecing. The choice is very personal—choose the method that suits you best.

Regardless of the method you choose, please read "Before You Mark and Cut" (page 10) before you begin.

This book offers a set of new patchwork block designs for making animals and birds. All kinds of oddly shaped geometric pieces are used to create the animal blocks.

These are the shapes for the Goldfinch.

The blocks are easy to sew, however, because all pieces are sewn together with straight seams. These straight seams give straight-line patchwork its name.

Most traditional patchwork patterns are made up of combinations of squares, rectangles, and triangles. In making animal designs, I wanted to use shapes that were different from these traditional shapes, yet I did not want to create blocks that were difficult to machine piece or had too many pieces in them. I achieved simplicity by having as few pieces as possible in each block and by joining them all with straight seams. There are no set-in seams in straight-line patchwork.

The concept behind straight-line patchwork is simple and not really original. It is the same concept that underlies a traditional Log Cabin block. Adding the Log Cabin pieces one at a time in a certain order allows you to sew only straight seams. The important principle is the *order in which you sew the pieces*. Similarly, in straight-line patchwork, the piecing order is the secret to success.

Like any other technique, straight-line patchwork has its own rules.

Rule Number 1: Follow the piecing order. To make the piecing order clear, each piece in the block is numbered.

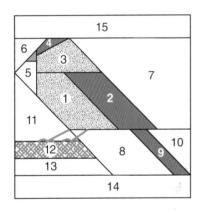

In the sewing directions, a plus sign indicates a seam. When the directions say 1 + 2, pick up pieces 1 and 2 and sew them together. Once joined, the pieces become a unit referred to as (1-2).

1 + 2 means to sew pieces 1 and 2 together.

Once sewn, the pieces are called (1-2).

The piecing order is given as a series of numbered steps that look like this:

1. 1 + 2
2. (1-2) + 3 + 4

These are the first two steps in piecing the Goldfinch block. First, you join pieces 1 and 2; second, you join pieces 3 and 4 to the unit you have just created (1-2).

Each step is numbered so you know exactly where you are, and each step represents either a seam or several seams that can be sewn without crossing each other. Following the piecing order is much like following a knitting pattern: you don't knit row 5 before you knit row 3!

In Log Cabin patchwork, all pieces are added on to the existing unit. In straight-line patchwork, pieces are sewn together into units that may be temporarily set aside while another unit is being sewn. Later, completed units are joined together into a larger unit or section.

One or more units make up each section of the block. Sections are indicated in the piecing order by a line of squiggles.

◆◆◆◆◆◆◆◆

When you see this line of squiggles, you know that you have completed one section of the design.

Turn to page 12 for step-by-step diagrams for assembling the block.

Rule Number 2: Lay out the block before you start. It is crucial to lay out each piece of the block in its correct position before you begin sewing. This helps you sew the correct sides of the pieces together. As you sew, put each completed unit back into the layout in the correct place.

Rule Number 3: Mark seam lines and corners clearly. There is a good reason for this, which you will discover when you actually sew two pieces together. The odd shapes in straight-line patchwork do not sit neatly on top of each other, with corners accurately matched like two squares or two identical triangles. Seam lines or corners must be marked so that pieces match up correctly at the corners.

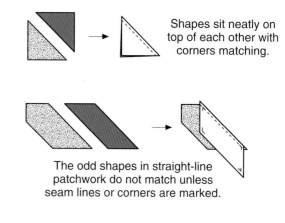

Shapes sit neatly on top of each other with corners matching.

The odd shapes in straight-line patchwork do not match unless seam lines or corners are marked.

Reproducing the Design

The first step in making all the animal blocks is to reproduce the design at full size. You can do this either by hand using a grid or by using a photocopier.

To enlarge the block design by hand:

The animal blocks in this book are all presented on grids. You will be making a larger grid, then drawing the animal onto it.

1. Choose a finished block size from the size options given with each design and note the size of the squares required. Copy the grid in the book onto graph paper or template plastic, making the squares the required size.

 Example: The Dolphin block is drawn on a grid of 12 squares x 12 squares. To make the block 12" x 12", make each square 1" x 1".

vertical - straight - hear snap - grid lines.
Run on straight of fabric

Use a colored pencil to draw the grid lines and a pencil or pen to draw the lines of the design so that you can distinguish between them.

NOTE: The *grid* lines also give you the *grain* lines for your block.

2. Use a pencil (or pen on template plastic) to draw the design onto the grid, referring to the original for placement. Draw the longest lines first. It is easy to draw the lines if you first mark the ends of each line with a dot, then use a ruler to join the dots.
3. Mark each piece with its correct number.
4. Color or add marks to the pieces, to help identify which pieces go with which fabrics.

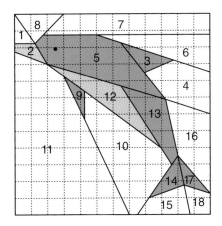

If you are coloring the pieces, use colors that relate to the colors you are using in the quilt. For example, in coloring the dolphin, use a dark color for the upper body, a light color for the lower body and nose, and leave the background blank. Don't spend a lot of time coloring—a quick sketch of color is all you need.

You can also use marks instead of color to identify pieces. For the Dolphin block, you could add diagonal lines to mark the pieces of the upper body, squiggle marks on the lower body and nose, and leave the background blank. Throughout this book, shading is used to identify color areas in each block design.

To photocopy the block design:

Yes, it is OK to photocopy the designs in this book for your own personal use! This is not usually recommended for templates, because the process of photocopying distorts the templates slightly; small distortions in one shape can add up to larger distortions when shapes are repeated or combined. With straight-line

patchwork, though, you copy the whole block, so any distortions balance themselves out.

1. Choose the block size you need for your quilt. The size of each design, as it is printed on the pages of this book, appears below the design. For example, the Dolphin design is 6" x 6". Below each design is a list of block sizes and the percentage by which you need to enlarge the design to make each size. To make the Dolphin block 9" x 9", you need to enlarge it by 150%. To make the block 12" x 12", you need to enlarge it by 200%. If the block is rectangular, base your enlargement on the measurement of the longest side.

Because many photocopiers can only enlarge up to 150%, enlargements greater than this must be done in two steps. The percentages are different in each step, so follow this handy table:

Two-Step Photocopy Enlargements
6" x 6" to 12" x 12" (a 200% enlargement)
 Step 1. Enlarge by 150% (to 9").
 Step 2. Enlarge by 133%.
5" x 5" to 10" x 10" (a 200% enlargement)
 Step 1. Enlarge by 150% (to 7½").
 Step 2. Enlarge by 133%.
6" x 6" to 10" x 10" (a 167% enlargement)
 Step 1. Enlarge by 133% (to 8").
 Step 2. Enlarge by 125%.

2. Photocopy the design. If the paper is not large enough, photocopy the top and bottom of the design separately and then tape the halves together.
3. Photocopiers are rarely totally accurate, so measure your photocopy and trim it to the exact size required. Be sure that the corners are square. Alter the least noticeable side, such as the back of the animal or where there are large background pieces.

Trim line

Freezer Paper → Reverse Image
I want other way
Retrace so have mirror image. Templates - turn over Reverse Image
Bring to print side

Before you begin to mark, cut, and sew the fabric, consider these essential points.

🦋 Which way should the animal face?

Most of the designs in this book are asymmetrical: the animal faces right or left. To make the design exactly as it appears on the page, place the templates right side down on the wrong side of the fabric. This is why cardboard templates must have grain lines marked on their reverse sides (page 11). To make a reverse image of the block (animal facing the opposite way), place the templates right side up on the wrong side of the fabric. It is important to be clear about this before you begin to mark so that you mark consistently.

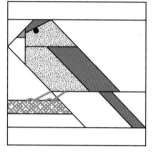 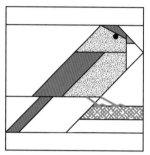

Mark with templates face down.

For reverse image, mark with templates face up.

🦋 Grain line is important.

It is important to keep grain line in mind as you mark your fabrics. The grain of the fabric is the direction in which the lengthwise and crosswise threads run in a piece of fabric. The bias grain is at a 45° angle to the lengthwise and crosswise grains. Whenever possible, keep the grain line consistent in a block. You may occasionally want to use a patterned fabric, such as a stripe, in a particular way that will result in its being off-grain. These exceptions are usually not a problem if other pieces in the block are kept on grain.

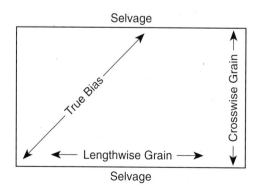

Tiny pieces can be introduced into a design by a process I call "tipping." Instead of making a tiny template, which can be exasperating to deal with, I treat the "tip" as part of the larger adjoining piece. Here's how:

1. Mark the tiny piece clearly on the template for the adjoining piece.

Template piece with "tip" marked

2. Mark and cut out the fabric, including seam allowance. Mark the seam line for the tiny piece on the wrong side of the fabric.

Mark sewing lines on wrong side of fabric.

3. Cut out a piece of fabric for the tiny piece you will "tip" in, cutting generously. Place this piece on top of the larger piece, right sides together, and pin.

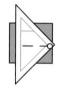

Pin small piece of fabric in place, right sides together.

4. Working on the wrong (marked) side, sew along the seam line.

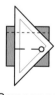

Sew across marked line.

5. Turn over to the right side, flip the small piece into place, and press. Trim away any unnecessary extra fabric beyond the seam allowance.

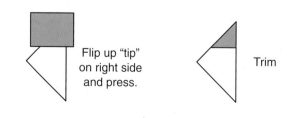

Flip up "tip" on right side and press.

Trim

Traditional Template Method

grainline
add ¼" if machine

MAKING TEMPLATES

Templates can be made from either template plastic or cardboard.

To make plastic templates:

1. Tape or paper-clip template plastic on your full-size design so that it does not move as you work. Trace the design with a fine-tip permanent marking pen. Find the ends of each line, mark them with a dot, then use a ruler to join the dots.
2. Transfer the piece numbers and add marks to identify the colors to be used; every piece that uses the same fabric should have the same marks.
3. Mark a grain-line arrow by transferring one of the grid lines from the pattern onto the template. I make all the grain-line arrows in one block run the same way (vertical or horizontal) so that I know which way to orient stripes or other directional prints.

4. Cut out the pieces. Cut around the outside edge first, then cut the longest lines, and finally the shortest.
5. Put a red dot sticker on the right side of each template.

Grain-line arrow
Piece number
1
Marks to identify color
Sticker

6. Store templates in large recycled business envelopes.

To make cardboard templates:

1. Using a glue stick (don't use other kinds of glue that wet and distort the paper), glue the full-size design onto the cardboard.
2. Cut out the pieces. Cut around the outside edge first, then cut the longest lines, and finally the shortest.
3. Mark grain lines on the wrong side of each piece. If one of the edges of the piece is parallel to a grid line, simply grasp that edge, turn the template over, and draw a grain-line arrow parallel to the same edge. If there is no parallel edge, push pins through the cardboard in two places along one of the grid lines. Turn the template over and draw a line between pin pricks.

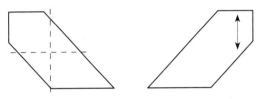

Where one edge is parallel to grain line, flip template over and mark with an arrow parallel to that edge.

Where there is no edge parallel to the grain line:
1. Push pins through template on grain line (grid line)
2. Flip the template over and mark the grain line between the two pin holes.

MARKING AND CUTTING THE FABRIC

1. Choose your fabrics, then sort your templates into piles according to fabric. For example, for the Goldfinch block, make a pile of the templates that will be black (2, 4, and 9), yellow (1 and 3), brown (12), and background (5–8, 10, 11, and 13–15).

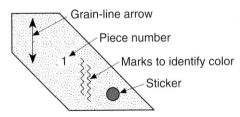

Yellow pieces Background pieces Black pieces Perch piece

2. Place the fabric right side down on a sandpaper board (page 5). Place the template on top of the

fabric, also right side down (or right side up for the reverse image). Match the grain of the fabric with the grain line marked on the template.

Place template wrong side up and match grain of fabric.

3. Leave at least ¾" between templates so that you have enough room for a ⅜"-wide seam allowance around each piece. Leave a generous 1" between very small pieces and long pointed pieces so you can cut a ½"-wide seam allowance. Larger seam allowances make it easier to pin and sew small pieces together accurately. You will trim the excess seam allowance after you sew the pieces together.

4. Using a sharp pencil, mark around the template, making sure that the corners are very clearly marked. It is not necessary to mark a cutting line.

5. Write the number of each piece in the seam allowance so that you can identify the pieces after they have been cut out.

Mark with template right side down on wrong side of fabric. Write piece number in seam allowance.

6. Transfer any "matching marks" onto the fabric. These two little crossing lines on some off-grain shapes will help you orient them as you sew. Most shapes are not a problem, but some off-grain shapes (especially triangles) can be confusing.

7. Cut out each piece, leaving a ⅜" seam allowance around medium and large pieces and up to ½" around smaller pieces.

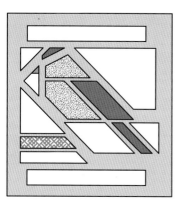

Cut out with ⅜"-wide seam allowances.

Cut out small and pointed pieces with ½"-wide seam allowances.

8. Place each piece in its correct position on your layout board (page 5). I lay out each piece as I cut, rather than leaving the layout until the end.

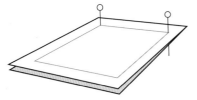

ASSEMBLING THE BLOCKS

Pinning

Right before you sew each seam, pin the pieces together, following this three-step routine.

1. **Corners:** Place the two pieces right sides together. Push a pin through the right-hand corner of the top piece, then turn the two pieces over and push the pin into the corner of the bottom piece (now on top). Repeat this procedure at the other corner. Do not bring the pins back up through the fabric. Accurate placement of these corner pins ensures that the corners are correctly aligned—this first step is the most important one.

2. **Seam line:** Holding the corners, gently adjust the pieces so the marked seam lines match up. Anchor the corner pins by bringing the points up through the line between them. Pin along the length of the marked seam line, placing pins with their heads pointing to the right. Note that the pins lie along the line. Check both sides to be sure you are pinning exactly along the seam lines.

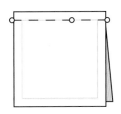

3. **Anchor:** Put an extra pin parallel to and below the pin at the left-hand corner as shown. The anchor pin holds the pieces in place as you remove the corner pin and begin stitching. Place vertical anchor pins at seam junctions, if any.

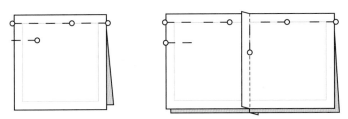

Machine Piecing and Pressing

1. Thread your machine with suitable thread. White thread is fine unless all of your fabrics are dark, in which case, use dark thread. Set the stitch length to between 10 and 12 stitches per inch for a neat stitch that is not too difficult to undo.
2. Set up your iron near your machine.
3. Following the piecing order carefully, pick up the first two pieces to be stitched together and pin as described on page 12. Take out the pin in the left-hand corner and place the cut edge below the needle, aligning the needle with the marked line. Start stitching at the cut edge and stitch along the marked line to the other cut edge. Pull out each pin right before it goes under the presser foot. Snip the thread ends and trim the seam allowances to an even ¼".

For machine piecing, stitch along marked line from cut edge to cut edge.

4. Press the seam allowances to one side unless instructed otherwise. (Occasionally, a block will lie flatter if some of the seams are pressed open.) Use the following guidelines to decide which way to press the seam allowances.
 - Press toward the darker fabric.
 - Press seams in opposite directions at seam intersections for precisely matched seams that lie flat.
 - Press seams in the direction they naturally go. Especially at bulky intersections, some seam allowances have a mind of their own, and it is best to go with the flow.
 - Press away from quilting lines; it is hard to quilt through bulky seam allowances.

5. Repeat with the remaining pieces in the block. Add embroidered or appliquéd details, if any. When the block is completed, trim the edges to the *exact* finished size required plus a ¼"-wide seam allowance all around. Your rotary cutter and large square ruler can help with this. Be ruthless.

Hand Piecing

1. Pin corners as described in first step on page 12.
2. Place additional pins at right angles to the seam line as shown.

Pin vertically for hand piecing.

3. Thread your needle with a color to match the darker fabric. Knot one end of the thread.
4. Begin stitching ⅛" in from one corner of the seam, stitching out toward the corner. Take a small stitch or two exactly in the corner, then turn and sew along the marked seam line with a running stitch. Pull the pins out as you come to them. When you reach the other corner, sew right to the corner, then turn and take a couple of stitches back along the seam line. End with a backstitch near the corner. Snip the thread ends.

Start and stop hand piecing away from the corner.

For hand piecing, stitch only along marked line and not into seam allowances.

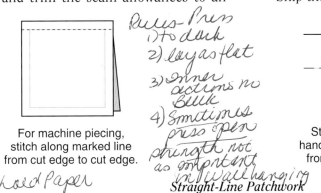

Handwritten notes: Rules - Press 1) to dark 2) lay as flat 3) inner actions no bulk 4) Sometimes press open — strength not as important in wallhanging

Handwritten note: Press - hold Paper

Straight-Line Patchwork

5. Following the piecing order, complete all seams in this manner. Note that, unlike machine piecing, you are not sewing into any seam allowances; seam allowances should be left free. When you come to an intersecting seam, sew right up to it, push your needle through the seam allowances, leaving them upright, and begin sewing on the other side.

Do not stitch down
any seams.

6. When the block is all stitched, trim the seam allowances and press them to one side as described for machine piecing.

TIP

In hand piecing, press the block *after* sewing all seams; in machine piecing, press each seam *as you go*.

7. Add embroidered or appliquéd details, if any, and trim the edges to the *exact* finished size required plus a ¼"-wide seam allowance all around.

Rotary-Cutting Method

The rotary cutter has revolutionized quiltmaking, so I have worked out a way to rotary cut the straight-line patchwork blocks. This method is only for the quilter who is experienced with the rotary cutter and totally comfortable cutting and sewing an exact, unmarked ¼" seam. If the finished seam allowance is not exactly the same as the cut seam allowance, your block will go sadly awry.

MAKING PAPER TEMPLATES

Rotary-cut straight-line patchwork still requires templates because of the odd shapes, but they can be simple ones made of paper. Paper templates are best for rotary cutting because they lie flat under the ruler. The paper copy you have already made of the design will work fine.

1. Cut the design apart along the lines and mark the grain line on the wrong side of each piece.

2. Place a ¾" strip of transparent tape in the middle of the *right* side of each paper template as shown. If you are making any reverse blocks, put tape on the wrong side as well.

CUTTING THE FABRIC

1. Cut off about 1½" of tape and roll it up into a small roll, sticky side out. Stick the roll onto the piece of tape in the middle of the paper template as shown.

2. Place your fabric wrong side up on your rotary-cutting mat. Place the template right side down on the fabric, matching grain lines. It should stick to the fabric.
3. Using a small ruler, line up one edge of the paper template with the ¼" mark on the ruler as shown. Cut along the edge of the ruler.

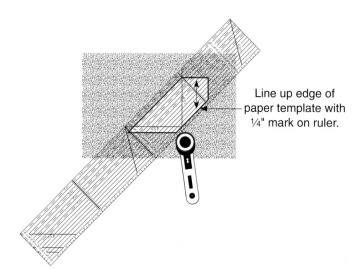

Line up edge of paper template with ¼" mark on ruler.

4. Move the ruler around and cut along each side of the template in the same way.

5. Using a sharp pencil, mark the corners clearly. Mark the number of the piece in the seam allowance. Remove the paper template.

NOTE: You need to mark the corners on the wrong side of each piece because they *must* match up.

6. Repeat this process for each piece in the block. It is best to cut the pieces out one at a time, rather than to stick all the templates on the fabric at once. Reuse the rolls of tape until they "run out of stick." Never leave tape on the fabric.

7. Place each piece in its correct position on your layout board (page 5). I lay out each piece as I cut, rather than leaving the layout until the end.

ASSEMBLING THE BLOCKS

1. Following the piecing order carefully, pick up the first two pieces to be stitched together and pin the corners as described on page 12. Align the cut edges along the length of the seam. Short seams may not require any more pins. Long seams may need another one or two pins.

Place vertical pins at seam intersections, if any.

2. Sew from cut edge to cut edge, being sure to stitch an exact ¼" seam (see the Tip box). It cannot be stressed enough that for the rotary-cutting method to work, you must sew exactly the same seam allowance you cut. Press.

3. Repeat with the remaining pieces in the block. Add embroidered or appliquéd details, if any. When the block is completed, trim the edges to the *exact* finished size required plus a ¼"-wide seam allowance all around. Your rotary cutter and large square ruler can help with this.

[handwritten: Fabric fused Paper glued / Press to wrong side]

Freezer-Paper Method

Freezer-paper piecing is the third way to make straight-line patchwork blocks. This method takes advantage of the way the coated side of freezer paper temporarily adheres to fabric when pressed. It can be both convenient and extremely accurate.

MAKING FREEZER-PAPER TEMPLATES

The first thing you need is a *reverse* image of the block design. The design must be copied onto the freezer paper in reverse because the freezer paper is pressed to the wrong side of the fabric. Of course, if you want your finished animal to be a reverse of the design, you can copy the design straight onto the freezer paper.

Image

Freezer paper must be marked from a reverse image.

1. Use a black pen to draw or trace the block design in reverse. One way to do this is to lay your drawn design or photocopy upside down on a plain sheet of white paper and trace the design on the wrong side. If the lines are not clear enough, push a pin through the paper at the points where lines meet. Turn the design over and connect the pin holes. Other alternatives are to place your copy upside down on a light box or tape it to a window and trace.

2. To trace the reverse image onto freezer paper, lay the freezer paper *shiny side down* on your reversed copy of the block design. Placing a sheet of white paper under all layers may help make the design more visible. *Draw only on the paper side.*

3. Number each piece, mark grain lines, and indicate fabric choices. Cut out each piece.

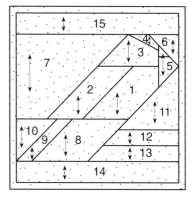

Copy reverse image of design onto freezer paper. Mark numbers and grain lines.

CUTTING THE FABRIC

1. Arrange the templates in piles according to fabric as described on page 11.

2. Place freezer-paper templates shiny side down on the wrong side of the fabric, matching the grain line on the template with the grain of the fabric. Leave ¾" between pieces for seam allowances. Press templates to fabric, using a hot, dry iron.

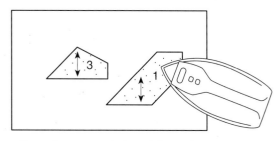

Press freezer-paper templates onto wrong side of fabric, leaving space for seam allowance around each template.

3. Cut out each piece in the design, leaving ¼"- to ⅜"-wide seam allowances all around each template. You can do this by eye—there is no need to measure seam allowances exactly.

4. Lay out the pieces on your layout board (page 8). Do not remove the freezer paper.

ASSEMBLING THE BLOCKS

1. Following the piecing order carefully, pick up the first two pieces to be stitched together and pin the corners as described on page 12. Place one or two pins in the seam allowance right next to the edge of the paper as shown.

Push pins through at corners and pin just along side of freezer paper in the seam allowance.

2. Take out the pin in the left-hand corner and place the cut edge below the needle, aligning the needle with the edge of the paper. Start stitching at the cut edge and stitch along the edge of the paper to the other cut edge. Pull out each pin right before it goes under the presser foot. Snip the thread ends and trim the seam allowances to an even ¼". Do not remove the freezer paper. Press.

Stitch along next to freezer paper.

3. Repeat with the remaining pieces in the block. When the block is completed, trim the edges to the exact finished size required plus a ¼"-wide seam allowance all around. Your rotary cutter and large square ruler can help with this. Gently remove the freezer paper.

4. Add embroidered or appliquéd details, if any.

TRADITIONAL BLOCKS FOR SETTINGS AND BORDERS

The quilts in this book combine straight-line patchwork animal blocks with traditional pieced blocks and/or borders.

Most traditional blocks are combinations of two simple shapes: the square and the right-angle triangle. Sometimes these shapes are combined to form other shapes, such as two squares making a rectangle or two triangles making a parallelogram.

The triangles in traditional blocks are generally created by dividing a square into halves or quarters. They are conveniently called half-square and quarter-square triangles, respectively.

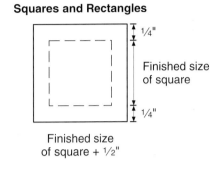

Half-square Quarter-square
triangle triangle

Rotary-Cutting Method

Measurements in the cutting directions for the traditional blocks in this book include ¼"-wide seam allowances. For quick and easy rotary cutting and machine piecing, cut squares and rectangles as directed and join pieces with an accurate ¼"-wide seam allowance (see the Tip box on page 15). There are many excellent books about rotary cutting, so I will describe the technique only briefly here.

NOTE: Measurements for each piece are given in the project directions. To determine the cut size of pieces in blocks you reduce, enlarge, or design yourself, see the Tip box at right.

DETERMINING CUTTING SIZE FOR SQUARES AND TRIANGLES

✎ For squares and rectangles, add ½" to the finished size.

Squares and Rectangles

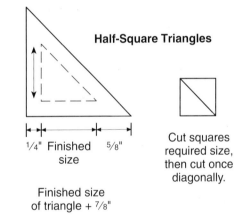

¼"

Finished size
of square

¼"

Finished size
of square + ½"

✎ For half-square triangles, cut a square that is ⅞" larger than the short sides of the finished triangle. Cut the square in half once diagonally to make two triangles.

Half-Square Triangles

¼" Finished size ⅝"

Finished size
of triangle + ⅞"

Cut squares
required size,
then cut once
diagonally.

✎ For quarter-square triangles, cut a square that is 1¼" larger than the long side of the finished triangle. Cut the square in half twice diagonally to make four triangles.

Quarter-Square Triangles

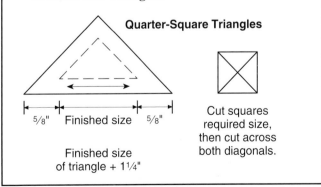

⅝" Finished size ⅝"

Finished size
of triangle + 1¼"

Cut squares
required size,
then cut across
both diagonals.

1. Using your rotary cutter and mat, square up one end of your fabric; fold the fabric in half with selvages matching and the fold next to you. Align one edge of a square ruler on the edge of the fold. Position a long ruler up against the square (at an exact right angle to the fold). Remove the square and cut.

2. Using the long ruler, cut strips the width required.

3. Crosscut the strips into squares or rectangles.

For triangles, first crosscut the strips into squares, then cut the squares diagonally either once (for half-square triangles) or twice (for quarter-square triangles) as shown.

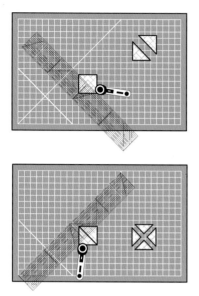

Template Method

If you feel more comfortable using templates, you will need to make a full-size drawing of each traditional block. Each project includes a miniature diagram of the traditional block. The finished size of the block and the number and size of squares in the grid are indicated next to each diagram.

MAKING TEMPLATES

1. Draw the block full-scale on a sheet of graph paper.
2. Determine what shapes you need to make the block and trace one of each shape onto template material (page 11).
3. Add a ¼"-wide seam allowance around each shape for machine piecing.
4. Cut the templates apart, place them right side down on the wrong side of your fabric, and draw around each template. Your sandpaper board will be useful for marking.
5. Cut out fabric pieces along the marked lines, which are your cutting lines.

NOTE: For hand piecing, make templates without seam allowances. For example, a 2" square in the finished block would require a 2"-square template. Mark, cut, and stitch the pieces as described on pages 13–14.

Piecing the Blocks

The Bias Square® technique developed by Nancy J. Martin is a quick and accurate way to make small half-square triangle units. For a full description of the method, see *Rotary Roundup* by Judy Hopkins and Nancy J. Martin.

1. Determine the cut size of the pieced square you need. If the finished size is 2" x 2", the cut size will be 2½" x 2½".
2. To prepare your fabrics for bias cutting, line up the 45° line on your ruler with a straight-grain edge of the fabric and cut along the edge of the ruler as shown. If you have a long piece of fabric, cut it into half-yard lengths first, then cut the bias strips.

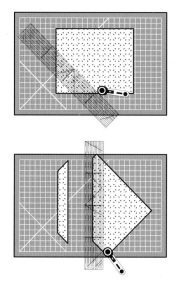

3. Cut bias strips from each of the two fabrics that make up the pieced square. Cut the strips the width of the cut size from step 1. In the example, you would cut the bias strips 2½" wide.
4. Sew the bias strips together, alternating fabrics. Press the seam allowances to one side, usually toward the darker fabric.
5. Using the Bias Square, cut squares from your joined strips by lining up the center line of the Bias Square with the seams. Note that some single triangles will result along the sides of the strips.

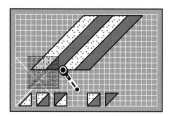

ASSEMBLING THE BLOCKS

1. Set up your machine for sewing an accurate ¼" seam (see the Tip box on page 15).
2. Place pieces with right sides together, matching cut edges. Sew from cut edge to cut edge, being sure to stitch an exact ¼"-wide seam.
3. Press the seam allowances to one side (page 13). Press intersecting seams in opposite directions whenever possible. This will keep intersections neat and flat.

Press seams in
opposite directions.

4. Although the piecing order is not as specific in traditional patchwork as in straight-line patchwork, try to sew small pieces into units, units into rows, and finally join the rows to complete the block.

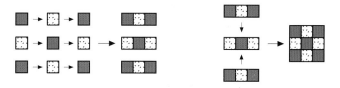

5. Many blocks include triangles that must first be sewn together into squares. An example is the Maple Leaf block.

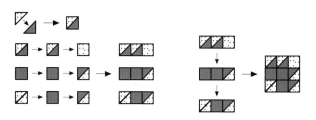

NOTE: If you use a Bias Square, you will have small triangles already joined together into squares, ready to be pieced into the larger block. Refer to the Tip box at left for the Bias Square technique.

Adding Details

Details such as eyes, legs, and ears bring the animals to life. These details can be appliquéd or embroidered, and you can also use buttons and beads.

APPLIQUÉ

Circles and Other Small Shapes

The following is the most accurate technique for circular eyes and ears.
1. Cut out the shape from lightweight cardboard. Round objects, such as buttons, coins, thimbles, and bottle lids, can help you draw perfect circles.
2. Cut the shape out of fabric, adding a ¼"-wide seam allowance all around the cardboard as shown.

3. Using basting thread in a contrasting color, sew a small running stitch about ⅛" from the edge of the fabric. Begin with a firm knot on the right side of the fabric and end by bringing the needle back out on the right side. Leave a few inches of thread dangling.

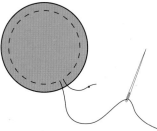

4. Place the cardboard shape in the center of the wrong side of the fabric and pull on both ends of the thread to gather the fabric closely around the cardboard. Tie the thread firmly and press well with a steam iron.

5. Remove the running stitch and trim the seam allowance to ⅛". Gently remove the cardboard.

6. Baste around the folded edge to hold the seam allowance in place.
7. Pin the prepared shape to the quilt, matching the grain line of the shape to the grain line of the background. Using thread that matches the color of the prepared shape, appliqué the shape in place.

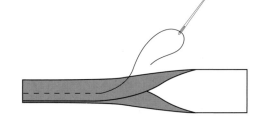

Bias Appliqué

The horns on the deer, the stripes on the chipmunk, and the stems of the Maple Leaf blocks are appliquéd bias strips.
1. Cut bias strips the width indicated in the instructions for each block.
2. Finger-press the strips into thirds lengthwise and baste the seam allowances down along the center of the strip as shown. Finger pressing keeps the strips supple for bending around curves.

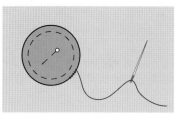

3. Cut the bias strips into the lengths required and appliqué in place. To finish the ends, tuck them under neatly, trimming any excess seam allowance as you go. Some ends, such as those in the Deer and Maple Leaf blocks, do not need to be finished because they will be caught in a seam.

Quick Bias Appliqué

This quick machine-appliqué method is particularly useful for wall hangings.

1. Cut strips about ¼" wide (you can use your rotary cutter).
2. Trim the ends to the shape required and pin the strips in place, smoothing them into nice curves as you go.
3. Set the sewing machine to a narrow zigzag stitch and stitch along the edge of the strip, around the end, and up the other side.

4. Tie off the thread ends at the back of your work and press. You don't need to back this appliqué with paper because the zigzag stitch should not stretch the fabric.

Other Shapes

Shapes that do not have to be exactly accurate, such as the cheek patches on the Flying Geese, can be added, using needle-turn appliqué.

1. Cut out the shape, adding ⅛"-wide seam allowances.
2. Pin and baste the shape in place, keeping the basting away from the edges where the seam allowances will tuck under. Appliqué in place, finger pressing the seam allowance under as you go.

NOTE: If part of the appliqué will be caught in a seam, allow a ¼"-wide seam allowance for this section of the shape. Press seam allowances under on either side of the section going into the seam and pin the piece in place. Stitch the seam. Appliqué the remainder of the shape, using the needle-turn method.

EMBROIDERY

You can make eyes, legs, and any other details on the birds and animals with some simple embroidery stitches.

Straight Stitch Stem Stitch Chain Stitch Lazy Daisy Stitch

Eyes

Here is an easy way to make eyes, using a chain stitch.

1. Thread your needle with two strands of embroidery thread.
2. Make a very small single chain stitch in the center. Then, using a very small chain stitch, embroider a ring of chains around the center stitch as shown. Continue in this manner until the circle is as large as required.

To make eyes with a color change, do the center and the first one or two rows of chain stitch in black, then change to another color around the outside.

You can add a highlight to the eye by making two small straight stitches in white, at a spot on the eye where you think the light would fall. This can be done to both appliquéd and embroidered eyes. The twinkle will give your animal a realistic look.

Legs

Embroider the legs and feet with either a chain stitch or stem stitch, depending on how thick a line you need. Stem stitch gives a finer line, chain stitch a thicker one. Make several lines of chain stitch if an even thicker line is required. Draw the lines lightly in pencil, then embroider over the pencil lines.

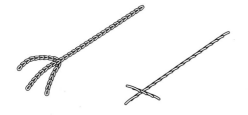

Beaks and Mouths

Beaks on the small birds can be sewn with straight stitches.

Mouths can be embroidered using a stem stitch.

Machine Embroidery

If you are confident using your machine for embroidery, add details by machine. For example, use a satin stitch for the bird legs. Follow the sewing machine manufacturer's instructions for the stitches involved. Always use a piece of paper at the back of your work to keep the fabric from puckering. Tear away the paper after the embroidery is complete.

BUTTONS AND BEADS

Buttons and beads can also be used to make eyes and noses. Look for small, suitable buttons and stitch them on with either a matching thread (if you don't want the stitching to show) or a contrasting thread (if you want the stitching to act as a highlight). Small seed beads make ideal eyes for the miniature bird blocks.

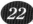

Adding Details

Constructing a Quilt

ASSEMBLING THE QUILT TOP

1. Piece the animal block(s) using straight-line patchwork. Trim blocks to the exact size required, plus ¼" all around for seam allowances.
2. Piece traditional blocks and/or cut other shapes required to make the quilt center.
3. Cut fabric for sashing if required.
4. Assemble the quilt as shown in the assembly diagram. In general, you will sew blocks into rows and then join the rows to make the center of the quilt top. If the quilt has sashing, join the blocks and sashing strips to make rows, then join the rows with sashing strips between them.

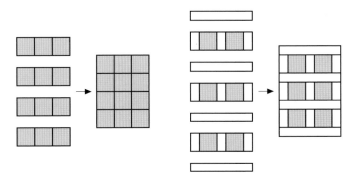

When you add a sashing strip between two rows of blocks, be careful to line up the blocks exactly opposite each other.

ADDING BORDERS

Borders may have straight-cut or mitered corners.

Straight-Cut Corners

1. Measure the length of the quilt top at the center, from raw edge to raw edge. Cut two border strips to that measurement. Mark the centers of the border strips and the sides of the quilt top. Join the border strips to the sides of the quilt, matching ends and centers and easing as necessary.

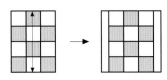

2. Measure the width of the quilt top at the center from raw edge to raw edge, including the border pieces you just added. Cut two border strips to that measurement. Mark the centers of the border strips and the top and bottom of the quilt top. Join border strips to the top and bottom of the quilt, matching ends and centers and easing as necessary.

For a variation on the straight-cut border, add corner squares.

1. Measure the length of the quilt top at the center, from raw edge to raw edge. Cut two border strips to that measurement.
2. Measure the width of the quilt top at the center, from raw edge to raw edge. Cut two border strips to that measurement.
3. Cut corner squares the same width as the borders, including seam allowances. For example, if the border strips are 3½" wide (cut size), make the corner squares 3½" x 3½".
4. Join the side border strips to the quilt top. Join a corner square to each end of the top and bottom strips, then join these units to the quilt top.

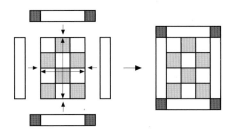

Mitered Corners

1. Estimate the finished outside dimensions of your quilt, including borders. Cut four border strips to that length, plus 2" to 3". If your quilt is to have multiple borders, join the individual border strips along the lengthwise edges with center points

matching, and treat the resulting unit as a single piece for mitering.

Make 4

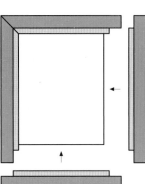

2. Mark ¼" seam intersections on all four corners of the quilt top. Mark the center of each side.

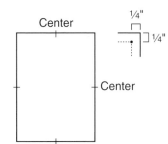

3. Mark the center of each border strip. Mark each end ¼" in from where the corner of the quilt will be.

| Corner of quilt | Center of quilt | Corner of quilt |

4. With right sides together, lay the border strip on the quilt top, matching centers and corner marks. Stitch from corner mark to corner mark and no farther. Open out. Repeat with remaining border strips. The stitching lines must meet exactly at the corners.

Right side

5. With right sides together, fold the quilt diagonally so that the border strips are aligned. Using a right angle or quilter's ruler marked with a 45° angle, draw a line on the wrong side of the top border strip, from the corner mark to the outside edge as shown.

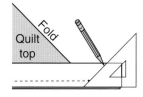

6. Secure borders with pins and stitch on the drawn line. Open out the top and make sure the seam is flat and accurate before trimming the seam allowances. Press the seam open. Repeat at remaining corners.

MARKING THE QUILTING DESIGN

Quilting patterns are many and varied. You can outline the patchwork pieces, fill in space with a grid and/or other designs, or do free-form quilting across the quilt surface. Mark quilting designs either before or after the layers are put together.

To mark before the layers are put together:
Use a sharp #2 pencil and mark lightly. Long rulers are helpful in drawing straight-line grids. To transfer designs, either cut quilting-pattern templates or stencils from plastic or cardboard and draw around them, or place a drawn pattern and the quilt top on a light box or window and trace.

To mark after the layers are put together:
Use chalk or masking tape to mark quilting designs right before stitching. Do not leave masking tape on the quilt top any longer than necessary; it leaves marks.

Constructing a Quilt

PIECING THE BACKING

In this book, yardage requirements for backings are based on 44"-wide fabric. Backings for quilts that finish wider than 40" must be pieced. Piecing can be done one of two ways.

❧ Cut crosswise strips from one end of the fabric. (The directions for each project specify the width.) Sew these strips together end to end. Press the seam allowances open. Sew the resulting unit to one long edge of the remaining piece of backing fabric as shown. Press the seam allowances open. Trim away the excess fabric.

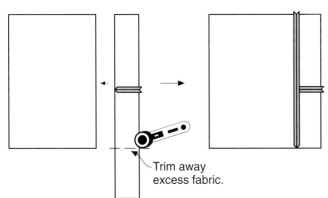

Trim away
excess fabric.

❧ Cut the backing fabric in half crosswise. Sew the halves together along the lengthwise edges (selvages) as shown. Press the seam allowances open.

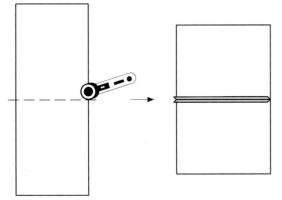

If you prefer unpieced backings, purchase 60"- or 90"-wide fabric and skip the piecing step. (You can even buy 108"-wide fabric, but you won't need it for any of the projects in this book.)

QUILTING

Hand Quilting

1. Prepare the backing, piecing as necessary. Make it 2" larger than the quilt top all around. Cut batting the same size as the backing.

2. Press the quilt top and mark the quilting designs (if appropriate).

3. Layer the backing, batting, and quilt top, making sure all layers are smooth and wrinkle-free.

4. Pin and baste the layers together, making a grid of basting stitches about 4" to 6" apart. Always pin or baste from the center of the quilt toward the edges.

5. Place the quilt in a hoop or frame, making sure that the layers are smooth and wrinkle-free.

6. If you are using chalk or masking tape, mark only the section you are about to stitch; complete this section before marking the next section.

7. Use quilting thread and a Between needle in a size that you find comfortable. Knot the thread end and gently pull the knot into the batting with your first stitch. Quilt with a small, even running stitch. The needle goes down vertically until it touches your finger beneath the quilt. Then rock it back upward to make a small stitch. Repeat this action several times before pulling the thread through, "stacking" stitches on your needle. Use thimbles to protect your fingers. End with a little backstitch, then run the thread through, into the batting, and snip it off.

8. Remove the basting.

Machine Quilting

The difficulty of fitting a quilt under the arm of a sewing machine makes machine quilting especially suited to small projects. If you wish to machine quilt a large quilt, you can overcome this limitation by quilting in an allover grid pattern (where the quilt is tightly rolled up and moved through the machine like a long sausage) or by making the quilt in smaller sections that you join after quilting.

1. Prepare the backing, piecing as necessary. Make it 2" larger than the quilt top all around.

2. Choose a thin, firm batting for machine quilting. Cut batting the same size as the backing.

3. Press the quilt top and mark the quilting designs (if appropriate).

4. Layer the backing, batting, and quilt top, making sure all layers are smooth and wrinkle-free.

5. Working from the center outward, pin the layers together with safety pins. (Pin basting is better than thread basting for machine quilting, since safety pins hold the layers together more firmly.) Leave the pins open until the entire surface is basted. Check to see that there are no wrinkles on the back, then close the safety pins. If you close the pins when you first put them in, the action of closing the pin may lift and rumple the layers.

6. Set up your sewing machine with plenty of clear table space beside and behind it. Attach a walking foot to the machine if you have one. This foot helps the three layers move smoothly together through the machine. Choose quilting thread to match or contrast with the quilt top, or use a clear monofilament thread that blends with all colors. (Monofilament thread also comes in a dark shade for dark fabrics.) Fill the bobbin with a thread that matches the backing fabric. Do not use monofilament thread in the bobbin.
7. If the quilt is large, roll or fold it neatly to fit under the machine.
8. Machine stitch the quilting design. Make sure that all three layers go through the machine evenly, using your fingers and hands to smooth the layers out in front of the presser foot. If you are using chalk or masking tape, mark only the section you are about to stitch; complete this section before marking the next section.
9. Remove the safety pins.

BINDING

Bind the outside edges of your quilt with double-fold binding. Use ¼"-wide seam allowances.

Cut binding strips four times the finished width, plus ½" for seam allowances. For example, cut 2½"-wide strips for a ½"-wide finished binding. (All the bindings in this book finish ½" wide.) Sew the binding to the quilt with either straight-cut corners or mitered corners.

Straight-Cut Corners

1. Measure the length of the quilt top through the center and cut binding strips to that measurement, piecing as necessary. Fold each strip in half lengthwise, right side out, and press.
2. Use pins to mark the center of each side of the quilt top. Mark the center of the binding strips.

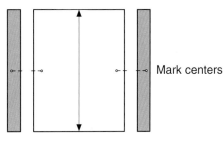

Mark centers

Measure center of
quilt, top to bottom.

3. Pin bindings to the side edges of the quilt, matching center marks. Stitch in place. Finger-press bindings away from the center of the quilt.

Quilt front
(already quilted)

4. Fold and finger-press the side bindings over to the back of the quilt and pin in place.

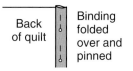

Back
of quilt

Binding
folded
over and
pinned

5. Measure the width of the quilt top through the center, including the side bindings, and cut strips to the measurements, piecing as necessary. Fold each strip in half lengthwise, right side out, and press.
6. Mark the center of the top and bottom edges of the quilt top. Mark the center of the binding strips.

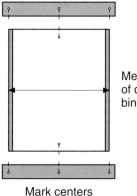

Measure center
of quilt, including
bindings.

Mark centers

7. Pin binding strips to the top and bottom of the quilt, matching center marks. Stitch in place.

8. Fold and finger-press the top and bottom binding strips over to the back of the quilt and pin in place. Blindstitch all four bindings in place, folding corner edges in neatly.

Mitered Corners

1. Measure the length of the quilt through the center. Mark the center of the quilt sides. Use pins to mark binding strips to this length and cut strips an extra 2" longer at each end. Fold strips in half lengthwise and press to mark the centers.
2. Pin binding strips to the sides of the quilt, matching center marks. Stitch the bindings in place, starting and stopping your stitching ¼" from the corners of the quilt. Refer to the illustration for mitered borders on page 24.

Quilt front
(already quilted)

3. Finger-press bindings away from the center of the quilt.
4. Repeat steps 1 and 2 to measure, cut, and mark the binding strips for the top and bottom edges of the quilt.
5. Pin binding strips to the top and bottom edges, matching center marks. Stitch the bindings in place as shown. Do not sew into the previously stitched side binding.

Stitch only to previous seam.

6. Fold and finger-press the binding over to the back of the quilt and pin in place. Blindstitch the binding in place, folding and trimming the corners neatly and stitching to make mitered corners.

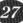

Dolphin block,
20" x 20".
Machine quilted.

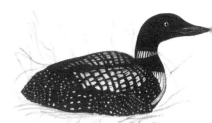

Turtle block,
18½" x 18½".
Machine quilted.

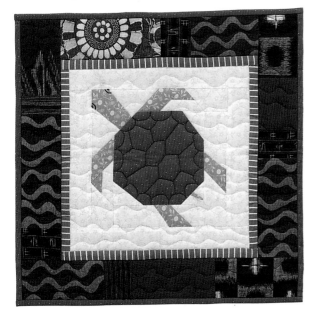

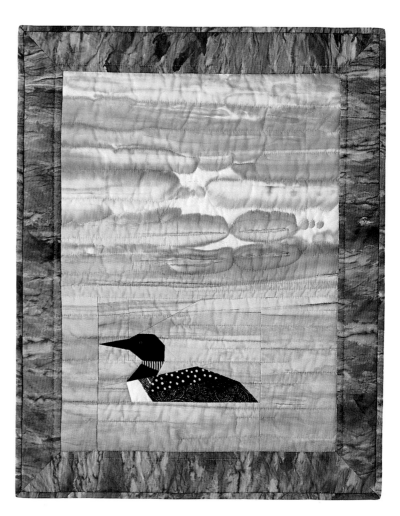

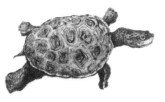

Loon block,
26" x 33".
Hand quilted by Trevor Reid.

Gallery of Blocks

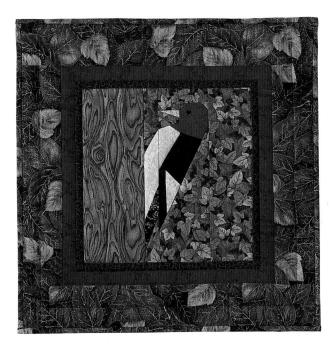

Woodpecker block,
21" x 21".
Machine quilted.

Chipmunk block,
27" x 27".
Machine quilted.

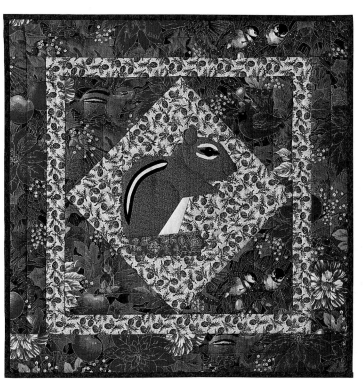

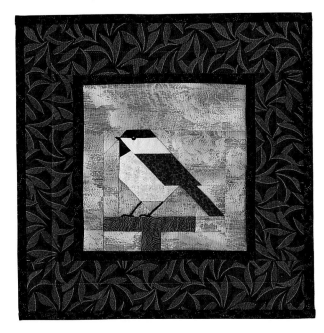

Chickadee block,
14" x 14".
Machine quilted.

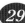

GOLDFINCH BLOCK

Block size shown: 6" x 6" • 1 square = ¾" • Trace or photocopy at full size.

Color Key

Follow this color key if you wish to make the goldfinch in its natural coloration.

■ Beak (orange)

▦ Breast and head (yellow)—1, 3

■ Wing, cap, and tail (black)—2, 4, 9

▨ Perch (brown)—12

□ Background—5, 6, 7, 8, 10, 11, 13, 14, 15

Piecing Order

1. 1 + 2
2. (1-2) + 3 + 4
3. "Tip" beak onto piece 5 as described on page 10.
4. (1-4) + 5
5. (1-5) + 6 + 7
6. 8 + 9 + 10
7. (1-7) + (8-10)
◆◆◆◆◆◆◆
8. 11 + 12 + 13
◆◆◆◆◆◆◆
9. (1-10) + (11-13)
10. (1-13) + 14 + 15

Sew on bead for eye; embroider legs.

Step 1

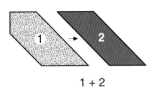

1 + 2

Step 2

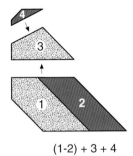

(1-2) + 3 + 4

Step 3

"Tip" beak onto
piece 5 (see p. 10)

Step 4

(1-4) + 5

Step 5

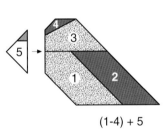

(1-5) + 6 + 7

Step 6

8 + 9 + 10

Step 7

(1-7) + (8-10)

Step 8

11 + 12 + 13

Step 9

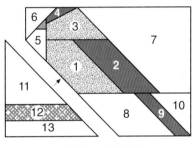

(1-10) + (11-13)

Step 10

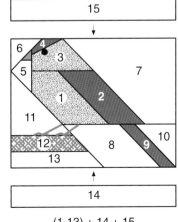

(1-13) + 14 + 15
Finishing: Sew on bead for
eye and embroider legs.

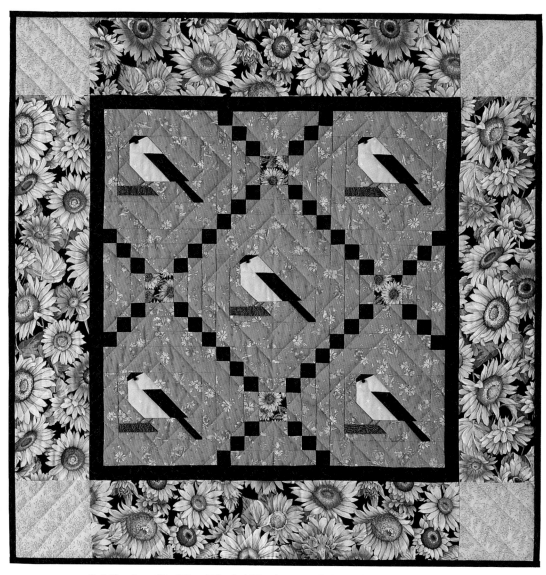

Goldfinch quilt, 37" x 37". Goldfinches nestle into the spaces between Chimney and Cornerstone blocks. Machine quilted by Judy Turner.

GOLDFINCH BLOCK

Finished size: 6" x 6"

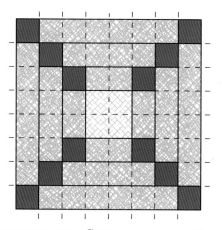

CHIMNEYS AND CORNERSTONES BLOCK

Finished size: 8" x 8"
8 squares x 8 squares
1 square = 1"

Materials: 44"-wide fabric

¾ yd. large yellow floral print for outer border
¾ yd. black print for bird wings, caps, and tails; Chimneys and Cornerstones blocks; inner border; and binding
¾ yd. green print for background
¼ yd. total of yellow prints for bird breasts and heads and corner squares
Small piece of brown print for perches
Small piece of yellow floral print for center squares in Chimneys and Cornerstones blocks
Scrap of orange print for bird beaks
42" x 42" piece of batting
1¼ yds. backing fabric
Brown embroidery floss
5 small black beads for eyes

Block Assembly

GOLDFINCH BLOCKS

1. Cut and piece 5 Goldfinch blocks, using one of the straight-line patchwork techniques on pages 7–16.
2. Embroider legs in chain stitch with 2 strands of brown embroidery floss (pages 21–22). Sew on beads for eyes.
3. Trim the finished blocks to 6½" x 6½".
4. From the background fabric, cut 4 strips, each 1½" wide; crosscut the strips to make:
 10 pieces, each 1½" x 6½"
 10 pieces, each 1½" x 8½"
5. Join 6½" pieces to the sides of a block, then sew 8½" pieces to the top and bottom of the block. Repeat with remaining blocks. Your blocks should now measure 8½" x 8½".

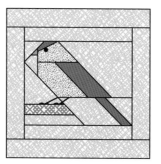

CHIMNEYS AND CORNERSTONES BLOCKS

1. From the green, cut 6 strips, each 1½" wide; crosscut the strips to make:
 16 pieces, each 1½" x 2½"
 16 pieces, each 1½" x 4½"
 16 pieces, each 1½" x 6½"
2. From the small piece of yellow floral print, cut 4 squares, each 2½" x 2½".
3. From the black, cut 2 strips, each 1½" wide; crosscut the strips to make 48 squares, each 1½" x 1½".
4. Assemble blocks as shown, making a total of 4 blocks.

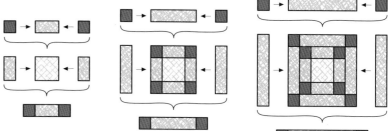

Quilt Top Assembly

1. Lay out the Goldfinch and Chimneys and Corner-stones blocks to make the quilt center as shown. Sew the blocks together into rows, then join the rows.

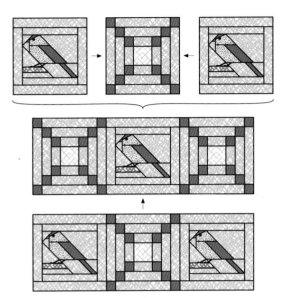

2. From the black, cut:
 - 2 strips, each 1½" x 24½"
 - 2 strips, each 1½" x 26½"
3. Join the 24½" strips to the sides of the quilt, then add the 26½" strips to the top and bottom as shown.

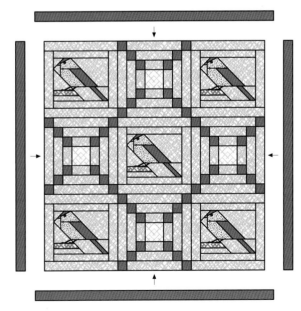

4. From the large yellow floral, cut 4 strips, each 6" x 26½" (outer border).
5. From the yellow print, cut 4 squares, each 6" x 6" (corner squares).
6. Sew a floral outer border strip to each side of the quilt. Join a yellow square to each end of the remaining floral strips, then add the resulting units to the top and bottom of the quilt as shown.

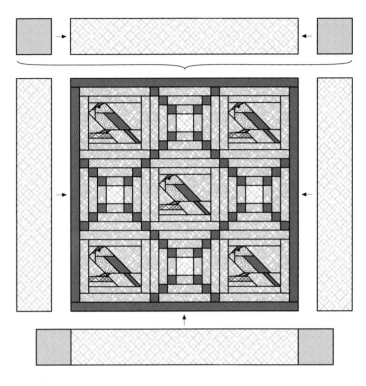

Quilt Finishing

1. Layer the quilt top with batting and backing; baste.
2. Quilt in the design of your choice.
 Suggested design: Outline-quilt the birds and perches. Quilt diagonal lines in both directions through the Chimneys and Cornerstones blocks, making 2 lines that just touch the corners of the small squares and continue through, into the borders. Quilt a diamond pattern around the birds. Continue the pattern of diagonal lines into the borders.
3. From the black, cut 4 strips, each 2½" wide. Bind the quilt, following the directions on page 26.

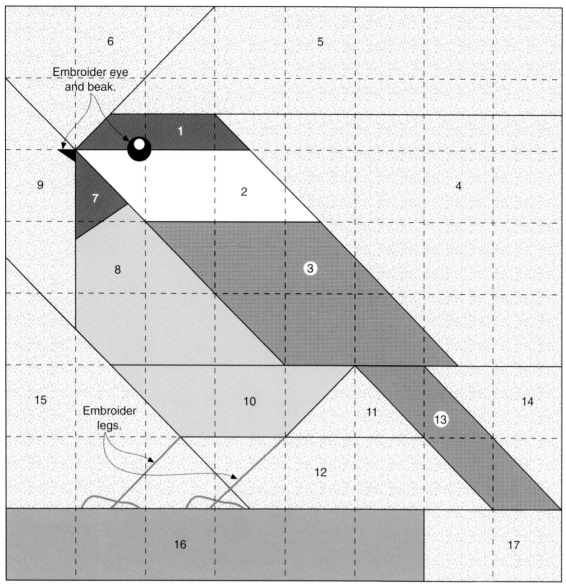

Embroider eye
and beak.

Embroider
legs.

CHICKADEE BLOCK
Block size shown: 6" x 6" • 1 square = ¾" • Trace or photocopy at full size.

Color Key

Follow this color key if you wish to make the chickadee in its natural coloration.

Head and bib (black)—1, 7

Cheek patch (white)—2

Breast and underbelly (cream or beige)—8, 10

Wing and tail (gray or brown)—3, 13

Perch (brown)—16

Background—4, 5, 6, 9, 11, 12, 14, 15, 17

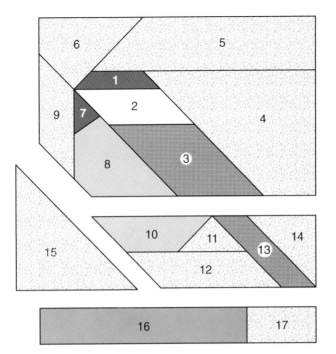

Major Block Sections

Piecing Order

1. 1 + 2 + 3
2. (1-3) + 4
3. (1-4) + 5
4. (1-5) + 6
5. 7 + 8
6. (7-8) + 9
7. (1-6) + (7-9)

◆◆◆◆◆◆◆◆

8. 10 + 11
9. (10-11) + 12
10. (10-12) + 13 + 14

◆◆◆◆◆◆◆◆

11. (1-9) + (10-14)
12. (1-14) + 15

◆◆◆◆◆◆◆◆

13. 16 + 17
14. (1-15) + (16-17)

Embroider beak, eye, and legs.

Chickadee Block

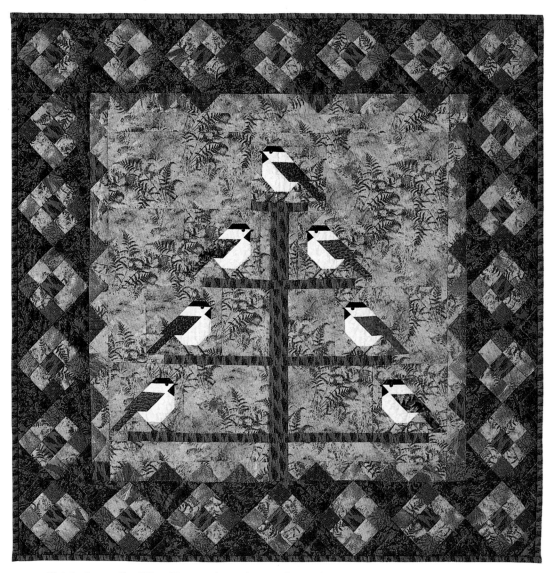

Chickadee quilt, 42" x 42". Borders of triangles and Ninepatches surround chickadees on a treelike perch. Hand quilted by Beth Miller.

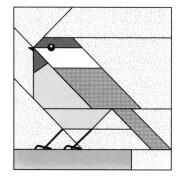

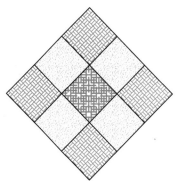

CHICKADEE BLOCK

Finished size: 6" x 6"

NINEPATCH BLOCK

Finished size: 4½" x 4½",
trimmed to 4¼" x 4¼"
3 squares x 3 squares
1 square = 1½"

Materials: 44"-wide fabric

1¼ yds. medium gray print for background
⅝ yd. dark green print for outer border
⅝ yd. dark pink print for perch, Ninepatch blocks, and binding
½ yd. total of assorted pink prints for pieced inner border and Ninepatch blocks
¼ yd. total of assorted dark gray prints for bird wings and tails
¼ yd. cream print for bird breasts and cheeks
Small piece of black print for bird heads and bibs
46" x 46" piece of batting
1⅝ yds. backing fabric
Black and dark gray embroidery floss

Block Assembly

CHICKADEE BLOCKS

1. Cut and piece 7 Chickadee blocks, using one of the straight-line patchwork techniques on pages 7–16. Make 4 regular blocks and 3 reverse blocks.
2. Using 2 strands of embroidery floss, embroider legs in gray with chain stitch, eyes in black with chain stitch, and beaks in black with some straight stitches (pages 21–22).
3. Trim the finished blocks to 6½" x 6½".

NINEPATCH BLOCKS

1. From the medium gray, cut 5 strips, each 2" wide; crosscut the strips to make 96 squares, each 2" x 2".
2. From assorted pinks, cut 5 strips, each 2" wide; crosscut the strips to make 100 squares, each 2" x 2". Reserve 4 squares for the pieced inner border.
3. From the dark pink, cut 2 strips, each 2" wide; crosscut the strips to make 24 squares, each 2" x 2".
4. Assemble blocks as shown, making a total of 24 blocks.

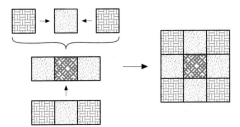

5. Trim the blocks ⅛" all around to 4¾" square.

Quilt Top Assembly

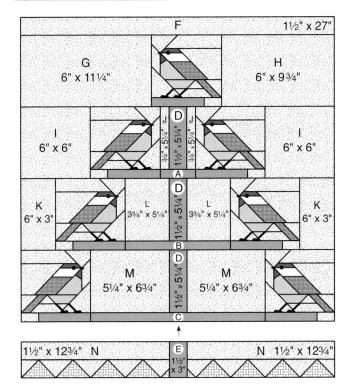

Measurements are finished size.

CUTTING CHART

Measurements are width x height and include ¼"-wide seam allowances.

Dark pink

A	3½" x 1¼"	(cut 1)
B	9½" x 1¼"	(cut 1)
C	15½" x 1¼"	(cut 1)
D	2" x 5¾"	(cut 3)
E	2" x 3½"	(cut 1)

Medium gray

F	27½" x 2"	(cut 1)
G	11¾" x 6½"	(cut 1)
H	10¼" x 6½"	(cut 1)
I	6½" x 6½"	(cut 2)
J	1¼" x 5¾"	(cut 2)
K	3½" x 6½"	(cut 2)
L	4¼" x 5¾"	(cut 2)
M	7¼" x 5¾"	(cut 2)
N	13¼" x 2"	(cut 2)

1. From the dark pink, cut:
 1 strip, 1¼" wide; crosscut the strip to make A, B, and C pieces.
 1 strip, 2" wide; crosscut the strip to make D and E pieces.
2. From the medium gray, cut:
 1 strip, 6½" wide; crosscut the strip to make G, H, I, and K pieces.
 1 strip, 5¾" wide; crosscut the strip to make J, L, and M pieces.
 2 strips, each 2" wide; crosscut the strips to make F and N pieces.
3. Lay out the center of the quilt as shown on facing page. Sew the pieces together into rows, then join the rows. *Do not sew the E and N pieces yet*. Press.

Borders

INNER BORDER

1. From the medium gray, cut:
 1 strip, 4¼" wide; crosscut into 8 squares, each 4¼" x 4¼". Cut each square in half *twice* diagonally for a total of 32 quarter-square triangles.
 4 squares, each 2⅜" x 2⅜". Cut each square in half *once* diagonally for a total of 8 half-square triangles.
2. From assorted pinks, cut:
 9 squares, each 4¼" x 4¼". Cut each square in half *twice* diagonally for a total of 36 quarter-square triangles.
3. Assemble the triangles and the 4 squares reserved from the Ninepatch blocks to make the inner border as shown.

Inner Border
Make 2

Side Inner Border
Make 2

4. Cut a 1" strip from the center of the bottom border as shown.

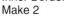

5. Sew a piece N to the top of each bottom border piece as shown. Join one of the resulting units to each side of piece E. Join to the bottom of the quilt.

6. Join the top inner border to the quilt, then add side inner borders.

OUTER BORDER

1. From the dark green, cut:
 2 strips, each 7¼" wide; crosscut the strips to make 10 squares, each 7¼" x 7¼". Cut each square in half *twice* diagonally for a total of 40 quarter-square triangles.
 1 strip, 3⅞" wide; crosscut the strip to make 8 squares, each 3⅞" x 3⅞". Cut each square in half *once* diagonally for a total of 16 half-square triangles.
2. Assemble Ninepatch blocks and green triangles to make outer borders as shown.

Top and Bottom Outer Border

Side Outer Border

3. Join side borders to quilt, then add top and bottom borders.

Quilt Finishing

1. Cut two 5" crosswise strips from one end of your backing fabric. Piece the backing, following the directions on page 25.
2. Layer the quilt top with batting and backing; baste.
3. Quilt in the design of your choice.
 Suggested design: Outline-quilt the birds and perch. Quilt a pattern of diagonal lines in the background. Outline-quilt the inner and outer borders. Quilt lines in outer border triangles.
4. From the dark pink print, cut 5 strips, each 2½" wide. Bind the quilt, following the directions on page 26 and joining strips as required.

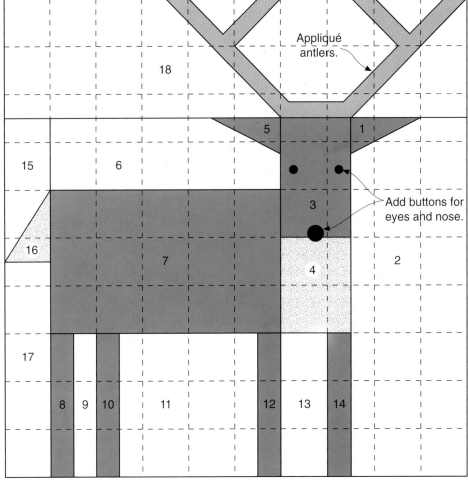

Appliqué antlers.

Add buttons for eyes and nose.

DEER BLOCK
Block size shown: 5" x 5" • 1 square = ½"

Color Key

Follow this color key if you wish to make the deer in its natural coloration.

Body (brown)—1, 3, 5, 7, 8, 10, 12, 14

Chest and tail (white)—4, 16

Background—2, 6, 9, 11, 13, 15, 17, 18

Antlers (light brown)—appliqué

Size Options

To enlarge from the grid (10 x 10 squares):
For a 10" x 10" block, 1 square = 1"

To enlarge by photocopying:
For a 10" x 10" block, enlarge by 200%.

Major Block Sections

Piecing Order

1. 1 + 2

◆◆◆◆◆◆◆◆◆

2. 3 + 4
3. 5 + 6 + 7
4. (3-4) + (5-7)
5. 8 + 9 + 10 + 11 + 12 + 13 + 14.
6. (3-7) + (8-14)

◆◆◆◆◆◆◆◆◆

7. 15 + 16
8. (15-16) + 17

◆◆◆◆◆◆◆◆◆

9. (1-2) + (3-14) + (15 -17)

◆◆◆◆◆◆◆◆◆

10. (1-17) + 18

Appliqué antlers using bias appliqué (page 20).
Sew on buttons for eyes and nose.

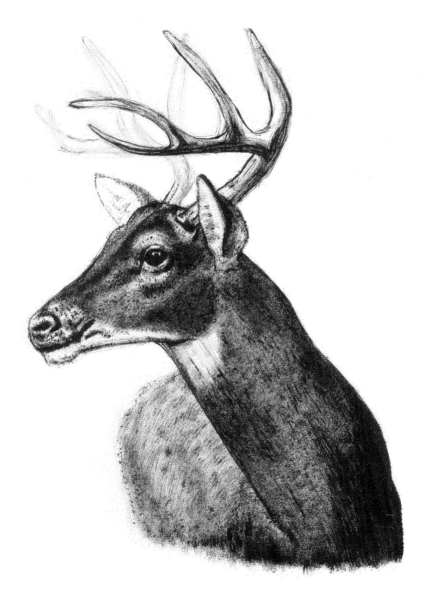

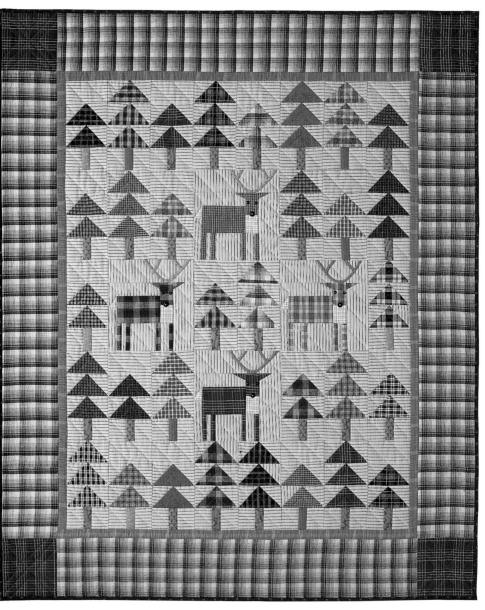

Deer quilt, 55½" x 65½". Four deer peer out of a simple patchwork forest. Hand quilted.

Short Tree Tall Tree

DEER BLOCK

Finished size: 10" x 10"
Enlarge the block on page 40 by 200%
or use a grid with 1" squares.

TREE BLOCKS

Finished size: 5" x 10"
2 squares x 4 squares
1 square = 2½"

Materials: 44"-wide fabric

1¾ yds. beige stripe for background
1⅛ yds. light maroon and blue plaid for outer border
1 yd. total assorted plaids for deer and trees
¼ yd. blue plaid for corner squares in outer border
¼ yd. mustard yellow plaid for inner border
¼ yd. total assorted brown prints for tree trunks
Small piece of mustard yellow print for antlers
Small piece of white plaid for deer chests and tails
60" x 70" piece of batting
3½ yds. backing fabric
½ yd. maroon print for binding
Four ½"-diameter black buttons for noses
Eight ⅜"-diameter black buttons for eyes

Block Assembly

DEER BLOCKS

1. Cut and piece 4 Deer blocks, using one of the straight-line patchwork techniques from pages 7–16.
2. Appliqué antlers, using bias appliqué (page 20). Cut bias strips ¾" wide. Note that the tops of the antlers will go into the seam at the top of each block.
3. Sew on black buttons for eyes and noses.
4. Trim the finished blocks to 10½" x 10½".

TREE BLOCKS

1. From the stripe, cut:
 7 strips, each 3" wide; crosscut the strips to make:
 16 rectangles, each 5½" x 3"
 64 rectangles, each 2½" x 3"
 7 strips, each 3⅜" wide; crosscut the strips to make:
 80 squares, each 3⅜" x 3⅜". Cut each square in half *once* diagonally for a total of 160 half-square triangles.
2. From assorted plaids, cut strips 6¼" wide; crosscut the strips to make 24 squares, each 6¼" x 6¼". Cut each square in half *twice* diagonally for a total of 96 quarter-square triangles. (You will have 16 triangles left over.)

3. From assorted brown prints, cut strips 1½" wide; crosscut the strips to make 32 rectangles, each 1½" x 3" (tree trunks).
4. Assemble blocks as shown, making 16 short trees and 16 tall trees.

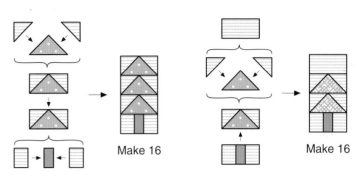

Make 16 Make 16

Quilt Top Assembly

1. Lay out the Deer and Tree blocks to make the quilt center as shown on page 44. Sew the blocks together into rows, then join the rows.
2. From the mustard yellow, cut 5 strips, each 1½" wide. Cut and join strips to make:
 2 strips, each 50½" long (side inner border)
 2 strips, each 42½" long (top and bottom inner border)
3. Sew 50½"-long strips to the sides of the quilt, then attach remaining strips to the top and bottom.
4. From the maroon and blue plaid, cut 5 strips, each 7¼" wide. Cut and join strips to make the following, matching the plaids at the seams:
 2 strips, each 52½" long (side outer border)
 2 strips, each 42½" long (top and bottom outer border)
5. From the blue plaid, cut 1 strip, 7¼" wide; crosscut the strip to make 4 squares, each 7¼" x 7¼" (corner squares).

6. Join 52½"-long outer borders to the sides of the quilt. Sew a corner square to each end of the remaining border strips, then add the resulting units to the top and bottom of the quilt as shown.

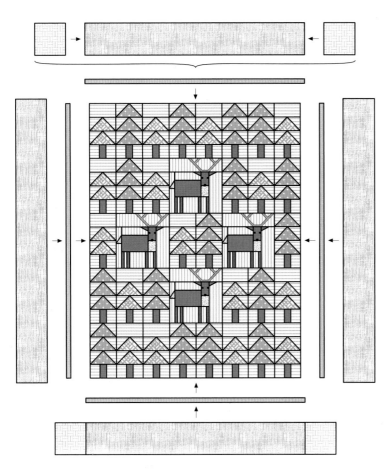

Quilt Finishing

1. Cut your backing fabric in half crosswise. Join the halves as described on page 25.
2. Layer the quilt top with batting and backing; baste.
3. Quilt in the design of your choice.
 Suggested design: Outline-quilt the deer and trees. Quilt a pattern of diagonal lines in the background. Quilt a triangle pattern inside the triangles of the trees. Outline-quilt the inner border. Quilt a pattern of straight lines in the outer border and a pattern of triangles in the corner squares.
4. From the maroon, cut 6 strips, each 2½" wide. Bind the quilt, following directions on page 26 and joining strips as required.

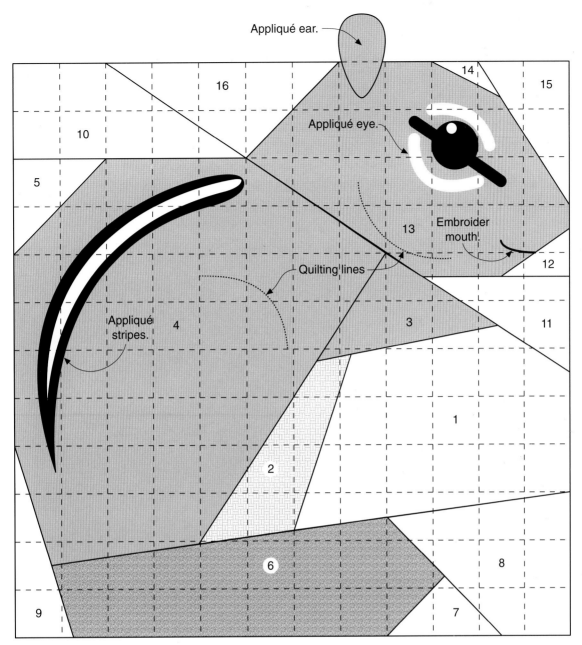

Appliqué ear.

Appliqué eye.

Embroider mouth.

Quilting lines

Appliqué stripes.

16 10 5 14 15 13 12 4 3 11 2 1 6 8 9 7

CHIPMUNK BLOCK
Block size shown: 6" x 6" • 1 square = ½"

Color Key

Follow this color key if you wish to make the chipmunk in its natural coloration.

▨ Body (brown)—3, 4, 13

▦ Tummy (beige)—2

▩ Tail (brown print)—6

☐ Background—1, 5, 7, 8, 9, 10, 11, 12, 14, 15, 16

Ear (brown) and stripes (black and beige)—appliqué

Size Options

To enlarge from the grid (12 x 12 squares):
For a 9" x 9" block, 1 square = ¾"

To enlarge by photocopying:
For a 9" x 9" block, enlarge by 150%.

Chipmunk Block

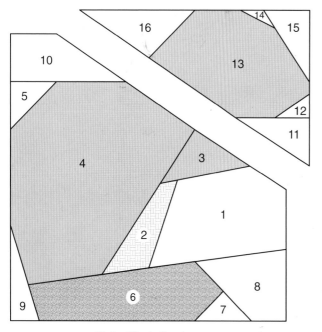

Major Block Sections

1. 1 + 2
2. (1-2) + 3
3. (1-3) + 4 + 5
4. 6 + 7
5. (6-7) + 8
6. (1-5) + (6-8)
7. (1-8) + 9 + 10

◆◆◆◆◆◆◆◆

8. 12 + 13 + 14
9. 11 + (12-14) + 15 + 16

◆◆◆◆◆◆◆◆

10. (1-10) + (11-16)

Appliqué stripes using bias appliqué (page 20). Appliqué eye and ear. Embroider mouth. Quilt leg and cheek.

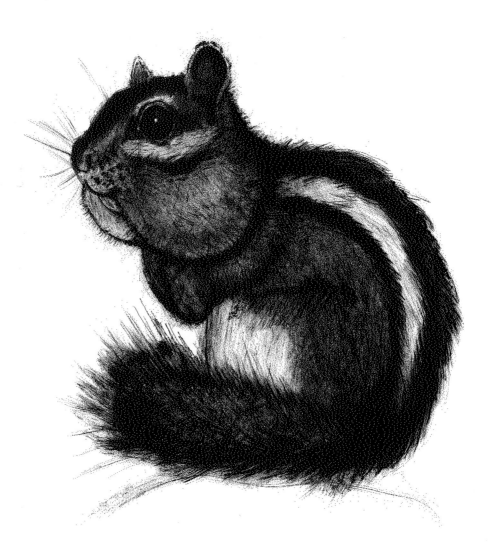

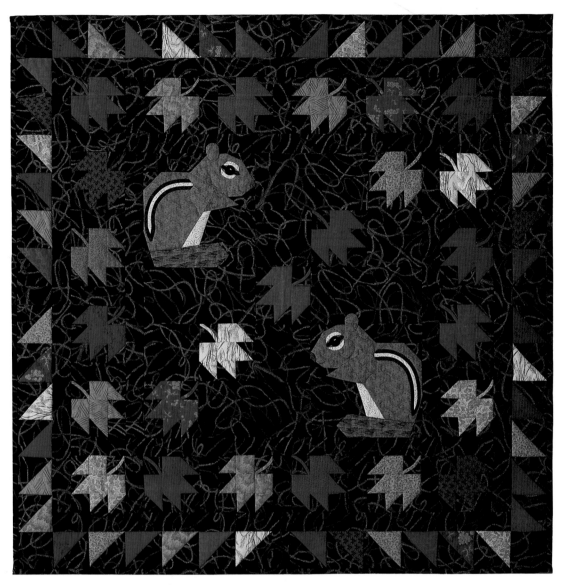

Chipmunk quilt, 43½" x 43½". Autumn-colored Maple Leaf blocks and a border of triangles frame these lifelike chipmunks. Machine quilted.

CHIPMUNK BLOCK

Finished size: 9" x 9"
Enlarge the block on page 45 by 150%
or use a grid with ¾" squares.

MAPLE LEAF BLOCK

Finished size: 4½" x 4½"
3 squares x 3 squares
1 square = 1½"

Chipmunk Quilt

Materials: 44"-wide fabric

2¼ yds. black print for background and binding
1 yd. total of assorted autumn-colored prints for Maple
 Leaf blocks and outer border
¼ yd. brown print for chipmunk bodies
Small piece of brown print for chipmunk tails
Scrap of beige print for chipmunk tummies and stripes
Scrap of black print for chipmunk stripes
Scrap of black solid for chipmunk eyes
48" x 48" piece of batting
1¾ yds. backing fabric
Brown embroidery floss

Block Assembly

CHIPMUNK BLOCKS

1. Cut and piece 2 Chipmunk blocks, using one of the
 straight-line patchwork techniques on pages 7–16.
 Make 1 regular block and 1 reverse block.
2. Appliqué stripes with beige and black prints, using
 bias appliqué (page 20). Cut bias strips ¾" wide. Ears
 will be appliquéd later.
3. Using 2 strands of brown floss, embroider chipmunk
 mouth.
4. Trim the finished blocks to 9½" x 9½".

MAPLE LEAF BLOCKS

For each block, cut the following:
1. From an autumn print, cut:
 3 squares, each 2" x 2"
 2 squares, each 2⅜" x 2⅜"; cut each square in
 half *once* diagonally for a total of 4 half-square
 triangles.
 1 bias strip, ¾" wide and 5" long
2. From the black, cut:
 2 squares, each 2" x 2"
 2 squares, each 2⅜" x 2⅜"; cut each square in half
 once diagonally for a total of 4 half-square
 triangles.

 NOTE: If you use the same background fabric
 for all the blocks, cut:
 3 strips, each 2"; crosscut the strips to
 make 50 squares.
 3 strips, each 2⅜"; crosscut the strips to
 make 50 squares. Cut each square in half
 once diagonally for a total of 100
 half-square triangles.

3. Join autumn triangles to black triangles to make 4
 pieced squares.

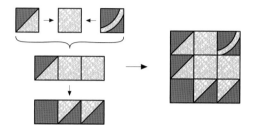

4. Prepare bias strip as shown on page 20 and appliqué
 to one background square.
5. Lay out the block and join the pieces together as
 shown.

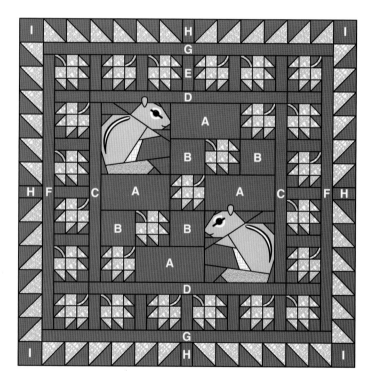

6. Repeat to make a total of 25 Maple Leaf blocks.

Quilt Top Assembly

Measurements are width x height and include ¼"-wide seam allowances.

A	9½" x 5"	(cut 4)
B	5" x 5"	(cut 4)
C	2" x 23"	(cut 2)
D	26" x 2"	(cut 2)
E	2" x 5"	(cut 20)
F	2" x 35"	(cut 2)
G	38" x 2"	(cut 2)
H	2" x 3½"	(cut 4)
I	3½" x 3½"	(cut 4)

1. From the black, cut:
 2 strips, each 5" wide; crosscut the strips to make A and B pieces.
 9 strips, each 2" wide; crosscut the strips to make C, D, E, F, G, and H pieces.
 3 strips, each 3⅞" wide; crosscut the strips to make 24 squares, each 3⅞" x 3⅞". Cut each square in half *once* diagonally for a total of 48 half-square triangles (outer border).
 Trim remainder of last strip to 3½" wide; crosscut to make 4 I pieces.
2. From the autumn-colored prints, cut strips 3⅞" wide; crosscut the strips to make 24 squares, each 3⅞" x 3⅞". Cut each square in half *once* diagonally for a total of 48 half-square triangles (outer border).
3. Lay out Chipmunk and Maple Leaf blocks as shown in quilt picture, balancing the colors of the leaves.

4. Assemble the center section of the quilt as shown.

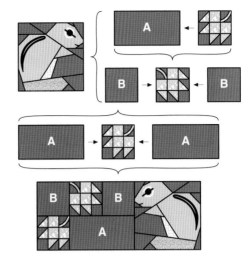

5. Sew C pieces to each side of the center, then add D pieces to the top and bottom.

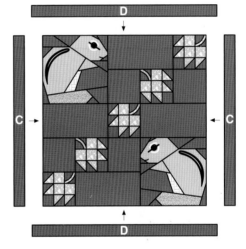

6. Appliqué ears on chipmunks with ovals of brown print (page 20).
7. To make the side border strips, join 4 Maple Leaf blocks and 5 E pieces. Refer to the Quilt Top Assembly diagram on page 48 for layout. Join to the sides of the quilt.
8. To make the top and bottom border strips, join 6 Maple Leaf blocks and 5 E pieces. Refer to the Quilt Top Assembly diagram on page 48 for layout. Join to the top and bottom of the quilt.

9. Sew an F piece to each side of the quilt, then add G pieces to the top and bottom.

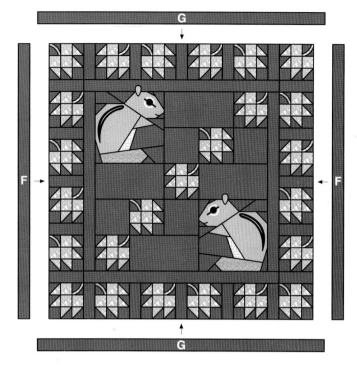

10. Join the autumn triangles to the black triangles to make 48 pieced squares.
11. Referring to the photo, arrange the squares around the quilt, balancing the colors. Join squares to make border strips, placing an H piece in the center of each border strip and an I piece at each end of 2 of the border strips as shown.

Make 2

Make 2

12. Sew side outer border strips to the quilt, then add top and bottom border strips.

Quilt Finishing

1. Cut two 6" crosswise strips from one end of your backing fabric. Piece the backing, following the directions on page 25.
2. Layer the quilt top with batting and backing; baste.
3. Quilt in the design of your choice.
 Suggested design: Outline-quilt the chipmunks and leaves. Quilt the back leg curve and the cheek on each chipmunk. Outline-quilt the colored triangles in the border. Free-motion quilt lines in background areas.
4. From the black, cut 5 strips, each 2½" wide. Bind the quilt, following the directions on page 26 and joining strips as required.

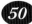

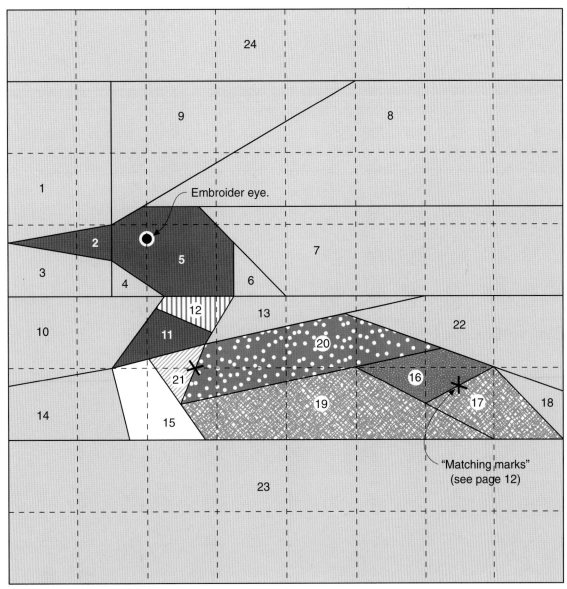

LOON BLOCK
Block size shown: 6" x 6" • 1 square = ¾"

Color Key

Follow this color key if you wish to make the loon in its natural coloration.

■ Beak, head, and neck (black)—2, 5, 11

▥ Neck band (black and white vertical stripes)—12

□ Breast (white)—15

▨ Shoulder (black and white diagonal stripes)—21

▧ Wing (black with white spots)—20

▨ Lower body and tail (black and white)—17, 19

▨ Lower wing (black print)—16

▨ Background—1, 3, 4, 6, 7, 8, 9, 10, 13, 14, 18, 22, 23, 24

Size Options

To enlarge from the grid (8 x 8 squares):
For a 12" x 12" block, 1 square = 1½"

To enlarge by photocopying:
For a 12" x 12" block, enlarge by 200%.

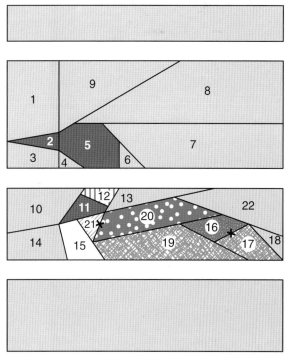

Major Block Sections

Piecing Order

1. 1 + 2
2. (1-2) + 3
3. 4 + 5 + 6
4. (4-6) + 7
5. (4-7) + 8
6. (4-8) + 9
7. (1-3) + (4-9)

◆◆◆◆◆◆◆◆◆

8. 11 + 12
9. 10 + (11-12) + 13
10. 16 + 17
11. (16-17) + 18
12. (16-18) + 19
13. (16-19) + 20
14. (16-20) + 21
15. 14 + 15 + (16-21) + 22
16. (10-13) + (14-22)
17. (1-9) + (10-22) + 23 + 24

Embroider eye with black center and red rim.

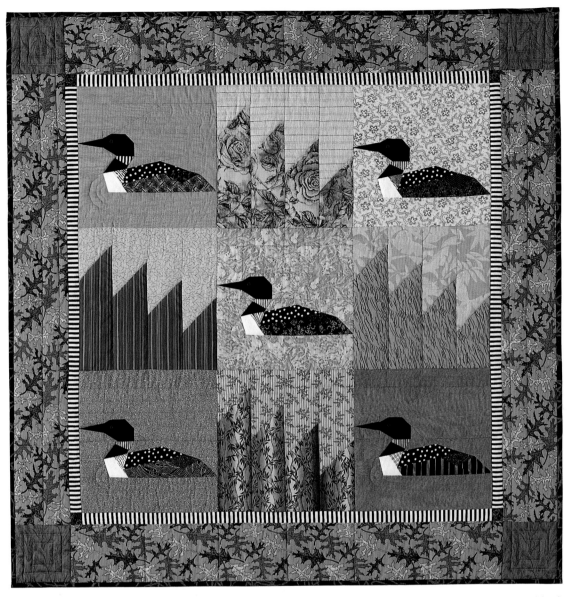

Loon quilt, 48" x 48". Loons swim between simply pieced blocks of reeds. Borders echo the crisp black and white of the birds and the soft greens of their lake environment. Machine quilted.

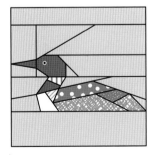

LOON BLOCK

Finished size: 12" x 12"
Enlarge the block on page 51 by 200%
or use a grid with 1½" squares.

REED BLOCK

Finished size: 12" x 12"
8 squares x 8 squares
1 square = 1½"

Materials: 44"-wide fabric

1¼ yds. total assorted light green prints for background
¾ yd. large-scale green print for outer border
½ yd. total of assorted dark green prints for reeds
¼ yd. black-and-white stripe for inner border
¼ yd. green print for corner squares in outer border
Small pieces for birds and corner squares:
 White solid for breasts
 Black solid for heads and necks
 Black with white spots for wings
 Black-and-white stripe for neck bands and
 shoulders
 Black print for lower wings
 Black-and-white print for lower bodies, tails,
 and corner squares in inner border
52" x 52" piece of batting
2¼ yds. backing fabric
½ yd. dark green print for binding
Black and red embroidery floss

Block Assembly

LOON BLOCKS

1. Cut and piece 5 Loon blocks, using one of the straight-line patchwork techniques on pages 7–16. Use a different background fabric in each block.
2. Using a chain stitch and 2 strands of embroidery floss, embroider eyes (page 21); make the center of the eye black and the outside red.
3. Trim the finished blocks to 12½" x 12½".

REED BLOCKS

For *each* block, cut the following:
1. From one of the assorted light green prints, cut 1 strip, 3½" wide; crosscut the strip to make rectangles in the following sizes:
 3½" x 5⅜"
 3½" x 6⅞"
 3½" x 8⅜"
 3½" x 9⅞"

2. From one of the assorted dark green prints, cut 1 strip, 3½" wide; crosscut the strip to make rectangles in the following sizes:
 3½" x 11⅜"
 3½" x 9⅞"
 3½" x 8⅜"
 3½" x 6⅞"

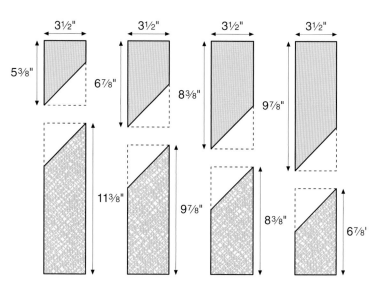

3. Trim rectangles across one corner on the diagonal as shown. Use the 45° angle marked on a quilt ruler or the diagonal center line of a Bias Square to help you make the cut.

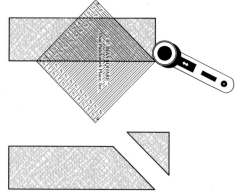

4. Assemble the Reed block as shown.

5. Repeat to make a total of 4 Reed blocks, using different fabrics in each block.

Quilt Top Assembly

1. Lay out the Loon and Reed blocks to make the quilt center as shown in the quilt diagram below. Sew the blocks together into rows, then join the rows.
2. From the black-and-white stripe, cut 4 strips, each 1½" wide (inner border). Trim each strip to 36½". From the black-and-white print, cut 4 squares, each 1½" x 1½" (corner squares).
3. Join inner border strips to the sides of the quilt. Join a corner square to each end of the remaining border strips, then add the resulting units to the top and bottom of the quilt as shown in the quilt diagram.
4. From the large-scale green print, cut 4 strips, each 5½" wide (outer border). Trim each strip to 38½".
5. From an additional green print, cut 1 strip, 5½" wide; crosscut the strip to make 4 squares, each 5½" x 5½" (corner squares).
6. Repeat step 3 for outer border.

Quilt Finishing

1. Cut two 11" crosswise strips from one end of your backing fabric. Piece the backing, following the directions on page 25.
2. Layer the quilt top with batting and backing; baste.
3. Quilt in the design of your choice.
 Suggested design: Outline-quilt the loons and reeds. Quilt a pattern of ripples in the background. Outline-quilt the inner border. Quilt a pattern of straight lines into outer border and corner squares.
4. From the dark green print, cut 5 strips, each 2½" wide. Bind the quilt, following the directions on page 26 and joining strips as required.

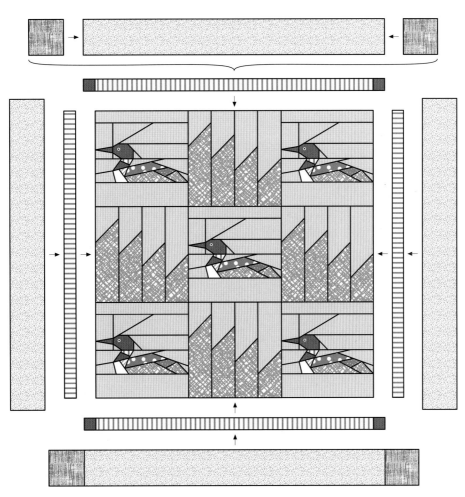

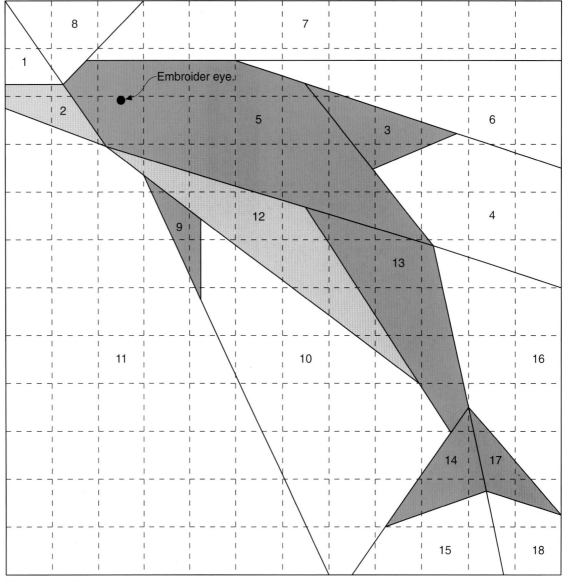

DOLPHIN BLOCK
Block size shown: 6" x 6" • 1 square = ½"

Color Key

Follow this color key if you wish to make the dolphin in its natural coloration.

☐ Nose and belly (light gray)—2, 12

■ Body (gray)—3, 5, 9, 13, 14, 17

☐ Background—1, 4, 6, 7, 8, 10, 11, 15, 16, 18

Size Options

To enlarge from the grid (12 x 12 squares):
For a 9" x 9" block, 1 square = ¾"
For a 12" x 12" block, 1 square = 1"

To enlarge by photocopying:
For a 9" x 9" block, enlarge by 150%.
For a 12" x 12" block, enlarge by 200%.

Major Block Sections

Piecing Order

1. 1 + 2
2. 3 + 4
3. (3-4) + 5
4. (3-5) + 6
5. (3-6) + 7
6. (3-7) + 8
7. (1-2) + (3-8)

◆◆◆◆◆◆◆

8. 9 + 10
9. (9-10) + 11
10. (9-11) + 12
11. (9-12) + 13
12. 14 + 15
13. (9-13) + (14-15)
14. 16 + 17 + 18
15. (9-15) + (16-18)

◆◆◆◆◆◆◆

16. (1-8) + (9-18)
Embroider eye.

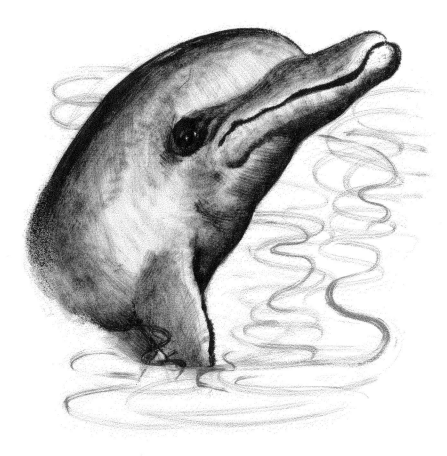

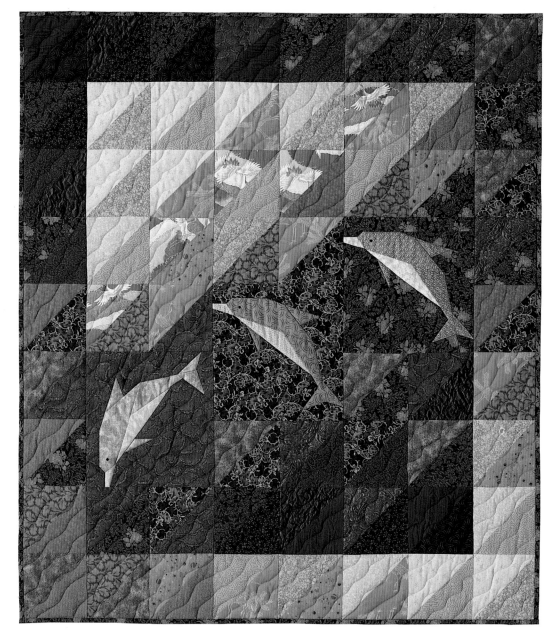

*Dolphin quilt, 48" x 54". Dolphins leap in a sea made of
shaded blue-green triangles. Machine quilted.*

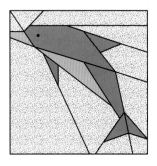

DOLPHIN BLOCK

Finished size: 12" x 12"
Enlarge the block on page 56 by 200%
or use a grid with 1" squares.

PIECED SQUARE

Finished size: 6" x 6"

Materials: 44"-wide fabric

2¾ yds. total assorted blue-green prints in a range of
 dark to light for background, including one print
 with a large white pattern
¼ yd. gray print for dolphin bodies
¼ yd. light gray print for dolphin noses and bellies
52" x 58" piece of batting
2¼ yds. backing fabric
½ yd. dark blue-green print for binding
Black embroidery floss

Block Assembly

DOLPHIN BLOCKS

1. Cut and piece 3 Dolphin blocks, using one of the
 straight-line patchwork techniques on pages 7–16.
 Use blue-green prints in medium values for the
 background.
2. Embroider eyes, using a chain stitch with 2 strands
 of black embroidery floss (page 21).
3. Trim the finished blocks to 12½" x 12½".

Quilt Top Assembly

1. Cut assorted blue-green fabrics into 6⅞" crosswise
 strips. You will need a total of 10 full-width strips.
 Crosscut the strips to make 60 squares, each 6⅞" x
 6⅞". Cut each square in half *once* diagonally for a
 total of 120 half-square triangles.
2. Working on a design wall (page 6), arrange the tri-
 angles in a pattern of light to dark, incorporating
 the white-patterned triangles and the dolphins as
 shown in the photo. Note that the light triangle is in
 the top left position and the dark triangle is in the
 bottom right in each square. This placement is re-
 peated in the center of the quilt, with lighter
 squares in the top left fading to darker ones at the
 opposite corner. Reversing this placement in the
 outside row of squares creates a border effect.
3. Join triangles into squares as shown.

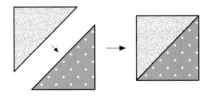

4. Sew Dolphin blocks and squares into vertical rows
 as shown. Join the rows.

Quilt Finishing

1. Cut two 11" crosswise strips from one end of your
 backing fabric. Piece the backing, following the di-
 rections on page 25.
2. Layer the quilt top with batting and backing; baste.
3. Quilt in the design of your choice.
 Suggested design: Outline-quilt the dolphins. Quilt
 a pattern of waves in the background.
4. From the dark blue-green, cut 6 strips, each 2½"
 wide. Bind the quilt, following the directions on
 page 26 and joining strips as required.

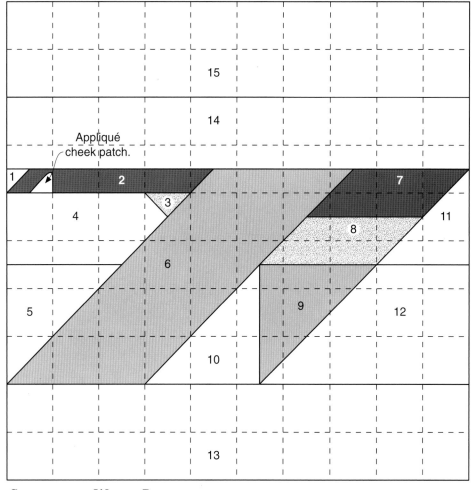

GOOSE WITH WINGS DOWN
Block size shown: 5" x 5" • 1 square = ½"

Color Key

Follow this color key if you wish to make the goose in its natural coloration.

■ Head and tail (black)—2, 7

▨ Breast and lower body (cream)—3, 8

▨ Wings (brown)—6, 9

□ Background—1, 4, 5, 10, 11, 12, 13, 14, 15

Cheek patch (white)—appliqué

Size Options

To enlarge from the grid (10 x 10 squares):
For a 10" x 10" block, 1 square = 1"

To enlarge by photocopying:
For a 10" x 10" block, enlarge by 200%.

Major Block Sections

Piecing Order

1. 1 + 2
2. 3 + 4 + 5
3. (1-2) + (3-5)
4. 7 + 8 + 9
5. (7-9) + 10
6. 11 + 12
7. (1-5) + 6 + (7-10) + (11-12)

◆◆◆◆◆◆◆◆

8. (1-12) + 13 + 14 + 15

Appliqué cheek patch.

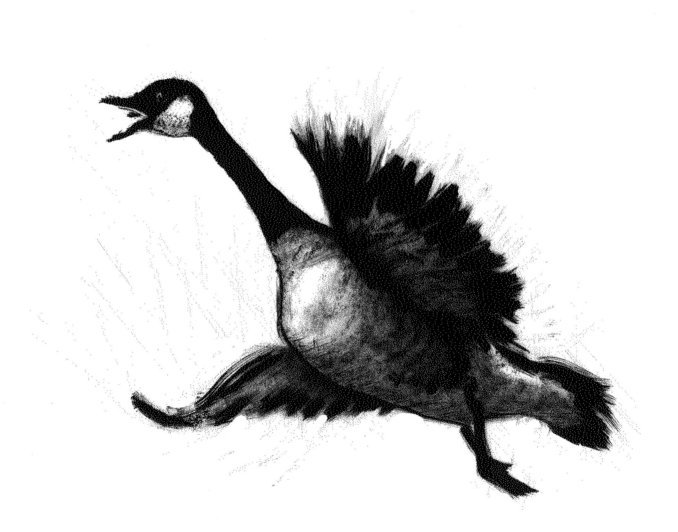

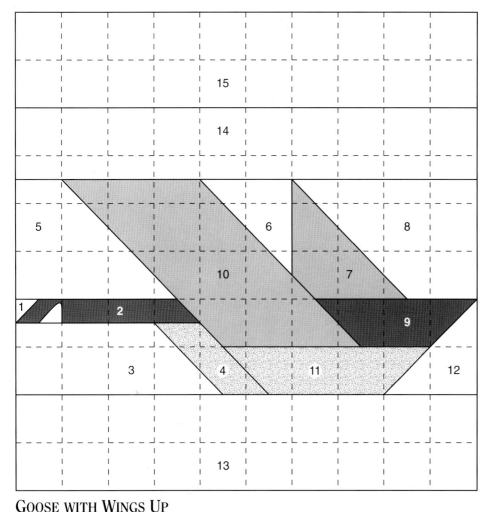

Color Key

Follow this color key if you wish to make the goose in its natural coloration.

■ Head and tail (black)—2, 9

▨ Breast and lower body (cream)—4, 11

▧ Wings (brown)—7, 10

□ Background—1, 3, 5, 6, 8, 12, 13, 14, 15

Cheek patch (white)—appliqué

Size Options

To enlarge from the grid (10 x 10 squares):
For a 10" x 10" block, 1 square = 1"

To enlarge by photocopying:
For a 10" x 10" block, enlarge by 200%.

GOOSE WITH WINGS UP
Block size shown: 5" x 5" • 1 square = ½"

Major Block Sections

Piecing Order

1. 1 + 2
2. 3 + 4
3. (1-2) + (3-4) + 5
4. 6 + 7 + 8
5. (6-8) + 9
6. (6-9) + 10
7. (6-10) + 11
8. (6-11) + 12
9. (1-5) + (6-12)

◆◆◆◆◆◆◆◆◆

10. (1-12) + 13 + 14 + 15
Appliqué cheek patch.

Flying Geese Blocks

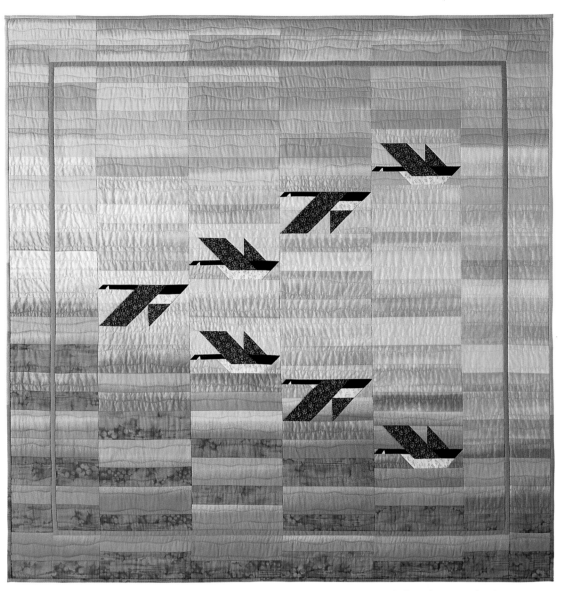

Flying Geese quilt, 60" x 60". Geese fly across a simply pieced sky of rectangles in sunset colors. Machine quilted.

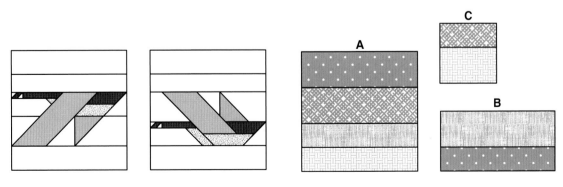

FLYING GEESE BLOCKS

Finished size: 10" x 10"
Enlarge the blocks on pages 60 and 62 by 200% or use a grid with 1" squares.

STRIP-PIECED BLOCKS

Block A finished size: 10" x 10"
Block B finished size: 10" x 5"
Block C finished size: 5" x 5"

Materials: 44"-wide fabric

4 yds. total assorted pastels in a range from light to medium dark for background and binding (hand-dyed fabrics are ideal)
¼ yd. lilac solid for inner border
¼ yd. brown print for geese wings
Small piece of black print for geese heads and tails
Small piece of beige print for geese bodies
Scrap of white print for cheek patches
64" x 64" piece of batting
3¼ yds. backing fabric

Block Assembly

STRIP-PIECED BLOCKS

The sky is composed of 2" and 3" strips joined to make square A blocks (10" x 10"), half-square B blocks (10" x 5"), and quarter-square C blocks (5" x 5") (finished sizes).

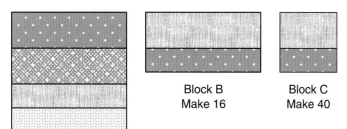

Block A
Make 11

Block B
Make 16

Block C
Make 40

1. From assorted sky fabrics, cut:
 19 strips, each 3½" wide; crosscut to make:
 52 pieces, each 10½" x 3½" (A and B blocks and Geese backgrounds)
 40 pieces, each 5½" x 5½" (C blocks)
 21 strips, each 2½" wide; crosscut to make:
 60 pieces, each 10½" x 2½" (A and B blocks and Geese backgrounds)
 40 pieces, each 5½" x 2½" (C blocks)

2. Place the pieces on a design wall (page 6). Arrange the colors and values to create the effect of a sunset (see photo), referring to the quilt diagram for block placement.

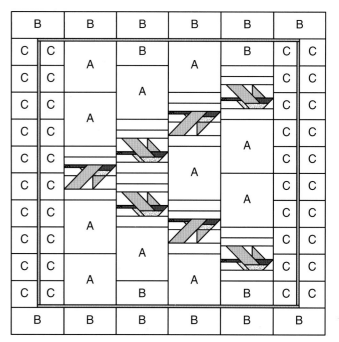

Note that each A block is composed of two 3" strips and two 2" strips. For nice color juxtapositions across the quilt, combine the widths differently in each block as shown. Vary the strips in the B and C blocks in a similar manner.

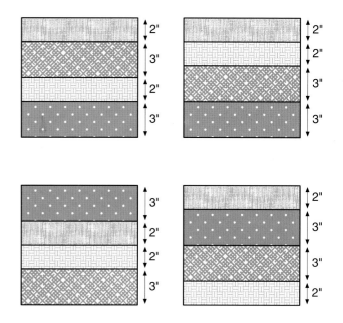

Next, fill in the spaces where the Flying Geese blocks will go. Since there are more horizontal seams in the Geese blocks, place 5 strips in each of these spaces instead of 4 (they will overlap for now). When you are ready to piece the Geese blocks, you will take strips from the wall to use as the background. This process preserves your sunset.

3. Sew pieces into blocks, making a total of 11 A blocks, 16 B blocks, and 40 C blocks. As you sew, replace each finished block on the layout wall. Leave the strips for the geese backgrounds unsewn.

FLYING GEESE BLOCKS

1. Cut and piece 4 Flying Geese blocks with wings up and 3 Flying Geese blocks with wings down, using one of the straight-line patchwork techniques from pages 7–16. Use the pieces from your layout for the background in each block.
2. Appliqué white cheek patches (page 20).
3. Trim the finished blocks to 10½" x 10½".

Quilt Top Assembly

1. Sew the blocks for the center of the quilt into vertical rows as shown. Join the rows.

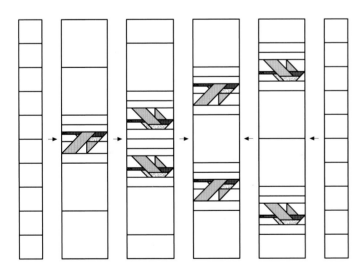

2. Trim the center of the quilt by ½" all around. It should now measure 49½" x 49½".

3. From the lilac solid, cut 5 strips, each 1" wide (inner border). Crosscut one of the strips into 4 pieces. Join one of these pieces to one end of each of the other 4 strips. Trim the pieced strips to make:
 2 strips, each 49½" long (side inner border)
 2 strips, each 50½" long (top and bottom inner border)
4. Join a 49½"-long strip to each side of the quilt, then add the 50½"-long strips to the top and bottom.
5. Join B and C blocks together to make border strips as shown. Join side border strips to the quilt, then add top and bottom border strips.

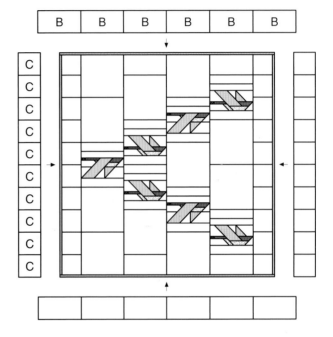

Quilt Finishing

1. Cut two 22" crosswise strips from one end of your backing fabric. Piece the backing, following the directions on page 25.
2. Layer the quilt top with batting and backing; baste.
3. Quilt in the design of your choice.
 Suggested design: Outline-quilt the geese. Quilt a pattern of wavy lines into the sky background. Outline-quilt the inner border.
4. From the assorted sky fabrics, cut approximately 6 strips, each 2½" wide. Select colors that will blend with the rest of the quilt (see photo). Bind the quilt, following the directions on page 26 and joining strips as required.

 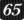

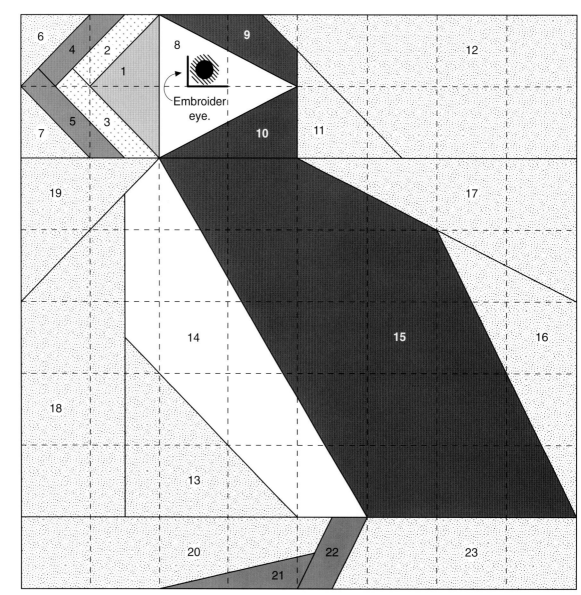

Embroider eye.

PUFFIN BLOCK
Block size shown: 6" x 6" • 1 square = ¾"

Color Key

Follow this color key if you wish to make the puffin in its natural coloration.

- Beak (blue)—1
- Beak (yellow)—2, 3
- Beak and feet (red)—4, 5, 21, 22
- Head and body (black)—9, 10, 15
- Cheek and breast (white)—8, 14
- Background—6, 7, 11, 12, 13, 16, 17, 18, 19, 20 23

Size Options

To enlarge from the grid (8 squares x 8 squares):
For an 8" x 8" block, 1 square = 1"
For a 10" x 10" block, 1 square = 1¼"

To enlarge by photocopying:
For an 8" x 8" block, enlarge by 133%.
For a 10" x 10" block, enlarge by 167%.

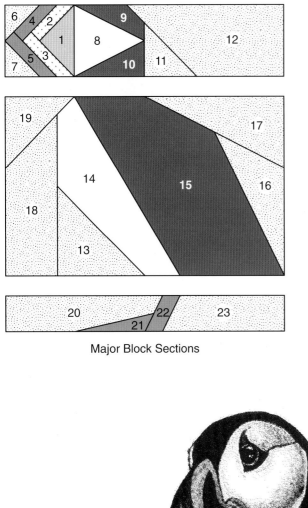

Major Block Sections

Piecing Order

1. 1 + 2
2. (1-2) + 3
3. (1-3) + 4
4. (1-4) + 5
5. (1-5) + 6
6. (1-6) + 7
7. 8 + 9
8. (8-9) + 10
9. (8-10) + 11
10. (8-11) + 12
11. (1-7) + (8-12)

◆◆◆◆◆◆◆◆

12. 13 + 14 + 15 + 16
13. (13-16) + 17
14. (13-17) + 18
15. (13-18) + 19

◆◆◆◆◆◆◆◆

16. 20 + 21
17. (20-21) + 22 + 23

◆◆◆◆◆◆◆◆

18. (1-12) + (13-19) + (20-23)
Embroider eye with black center, red rim, and black lines as shown.

Puffin Block

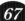

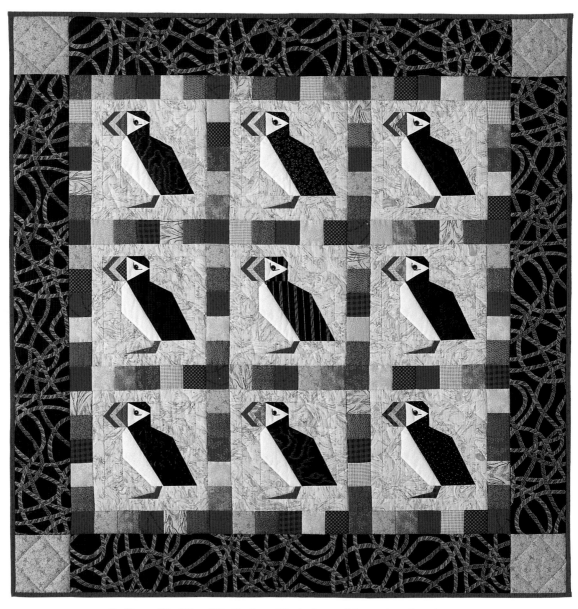

Puffin quilt, 48" x 48". Each puffin is framed by a pieced sashing that echoes the bright coloring of its beak. Machine quilted.

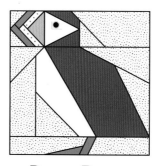

PUFFIN BLOCK

Finished size: 8" x 8"
Enlarge the block on page 66 by 133%
or use a grid with 1" squares.

Materials: 44"-wide fabric

1 yd. light blue print for background
¾ yd. total assorted red prints for puffin beaks and feet, sashing, and binding
¾ yd. black and multicolored print for border
½ yd. total assorted black prints for puffin heads and bodies
½ yd. total assorted yellow prints for puffin beaks, sashing, and corner squares
⅜ yd. total assorted blue prints for puffin beaks and sashing
¼ yd. white solid for puffin cheeks and breasts
52" x 52" piece of batting
2¼ yds. backing fabric
Black and red embroidery floss

Block Assembly

PUFFIN BLOCKS

1. Cut and piece 9 Puffin blocks, using one of the straight-line patchwork techniques from pages 7–16.
2. Embroider eyes in chain stitch, using 2 strands of embroidery floss; make the center of the eye black and the outside red (page 21). Using a stem stitch, embroider lines above and to the right of the eye as shown in the block diagram.
3. Trim the finished blocks to 8½" x 8½".
4. From background fabric, cut 9 strips, each 1½" wide; crosscut the strips to make:
 18 pieces, each 1½" x 8½"
 18 pieces, each 1½" x 10½"
5. Join the 8½" strips to the sides of the blocks, then add the 10½" strips to the tops and bottoms of the blocks. Your blocks should measure 10½" x 10½".

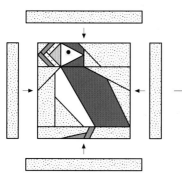
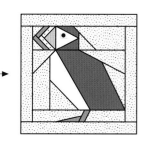

Quilt Top Assembly

1. From assorted red prints, cut 2½"-wide strips; cross-cut the strips to make 40 squares, each 2½" x 2½".
2. From assorted blue prints, cut 2½"-wide strips; cross-cut the strips to make 48 squares, each 2½" x 2½".
3. From assorted yellow prints, cut 2½"-wide strips; crosscut the strips to make 48 squares, each 2½" x 2½".

NOTE: You will need approximately 3 full-width strips of each color. For more variety, use shorter strips of a larger number of fabrics.

4. Lay out the squares for the sashing strips, keeping to a sequence of red, yellow, blue from left to right across the horizontal sashing and red, yellow, blue from top to bottom along the vertical sashing (see photo). All of the corner squares should be red.
5. Join squares to make the 12 vertical sashings and 4 horizontal sashings as shown.

Make 4

Make 12

6. Sew Puffin blocks and vertical sashings into rows.

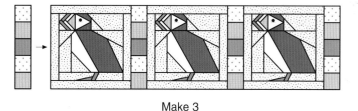

Make 3

7. Join the rows to the horizontal sashings to complete the center as shown.

8. From the black print for the border, cut 4 strips, each 5½" wide. Trim each strip to 38½".

9. From one of the yellow prints, cut 4 squares, each 5½" x 5½" (corner squares).

10. Join a black border to each side of the quilt. Join a yellow square to each end of the remaining border strips, then add the resulting units to the top and bottom of the quilt.

Quilt Finishing

1. Cut two 11" crosswise strips from one end of your backing fabric. Piece the backing, following the directions on page 25.

2. Layer the quilt top with batting and backing; baste.

3. Quilt in the design of your choice.
 Suggested design: Outline-quilt the birds. Free-motion quilt in the bird backgrounds. Outline-quilt around the blocks and around the inner edge of the outer border. Quilt straight lines outward through the outer border. Quilt a diamond pattern into the corner squares.

4. From the red print, cut 5 strips, each 2½" wide. Bind the quilt, following the directions on page 26 and joining strips as required.

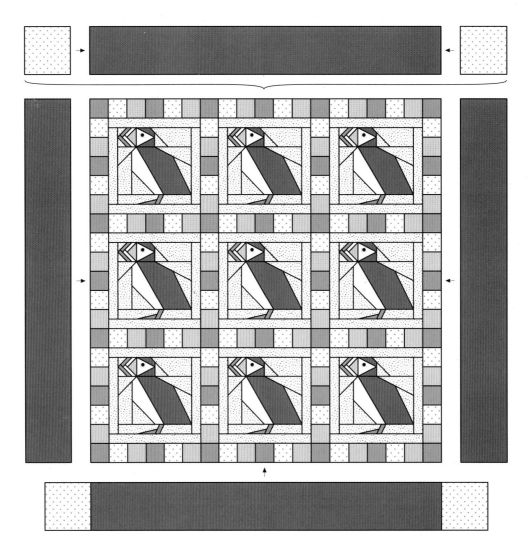

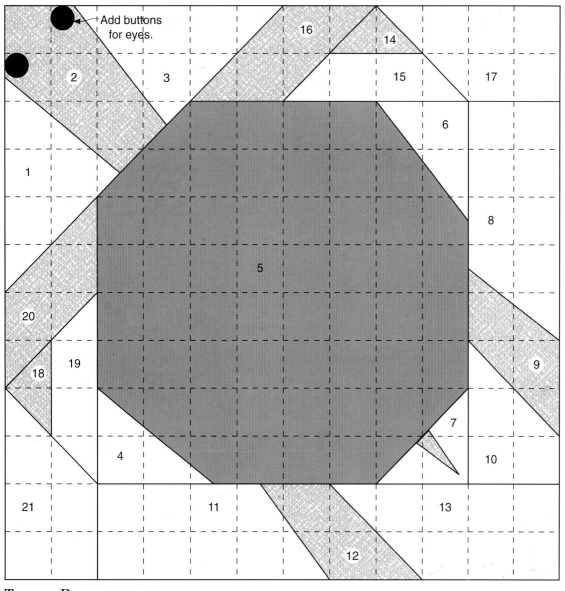

Add buttons for eyes.

TURTLE BLOCK
Block size shown: 6" x 6" • 1 square = ½"

Color Key

Follow this color key if you wish to make the turtle in its natural coloration.

■ Shell (brown)—5

▨ Head, limbs, and 3-dimensional tail (light brown)—2, 9, 12, 14, 16, 18, 20

□ Background—1, 3, 4, 6, 7, 8, 10, 11, 13, 15, 17, 19, 21

Size Options

To enlarge from the grid (12 x 12 squares):
For a 9" x 9" block, 1 square = ¾"
For a 12" x 12" block, 1 square = 1"

To enlarge by photocopying:
For a 9" x 9" block, enlarge by 150%.
For a 12" x 12" block, enlarge by 200%.

Major Block Sections

Piecing Order

1. 1 + 2 + 3

◆◆◆◆◆◆◆◆◆

2. 4 + 5 + 6

Construct 3-dimensional tail from small triangle of fabric (see below) and pin in place on piece 7.

3. (4-6) + 7
4. 8 + 9 + 10
5. (4-7) + (8-10)
6. 11 + 12 + 13
7. (4-10) + (11-13)
8. 14 + 15
9. (14-15) + 16 + 17
10. (4-13) + (14-17)
11. 18 + 19
12. (18-19) + 20 + 21
13. (4-17) + (18-21)

◆◆◆◆◆◆◆◆◆

14. (1-3) + (4-21)

Sew on buttons for eyes.

TAIL

1. Cut out triangle.
2. Fold and stitch.
3. Trim away end.
4. Turn right side out. Press.

1. Cut out triangle. 2. Fold and stitch

1¼"

1¾"

3. Trim away end. 4. Turn right side out. Press.

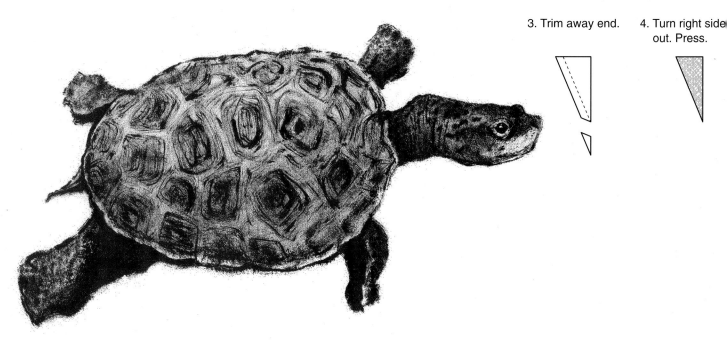

Turtle Block

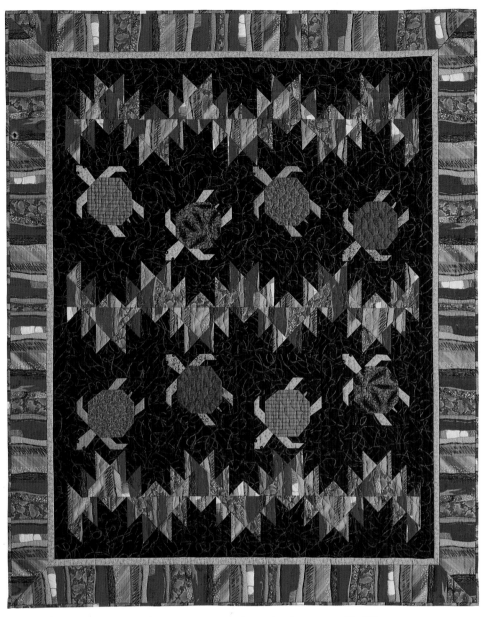

*Turtle quilt, 64" x 76". Turtles swim in a sea of brilliant
Delectable Mountains blocks. Machine quilted.*

TURTLE BLOCK

Finished size: 9" x 9"
Enlarge the block on page 71 by 150%
or use a grid with ¾" squares.

DELECTABLE MOUNTAINS BLOCKS

Finished size: 6" x 12"
3 squares x 6 squares
Half-block size: 6" x 6"
3 squares x 3 squares
1 square = 2"

Materials: 44"-wide fabric

3 yds. bright multicolored print for Delectable Mountains blocks, outer border, and binding

2¾ yds. black print for background and inner border

½ yd. total of assorted light green prints for turtle heads, legs, and tails and center border

½ yd. total of assorted green prints for turtle shells

68" x 80" piece of batting

4 yds. backing fabric

16 small black buttons for eyes

Block Assembly

TURTLE BLOCKS

1. Cut and piece 8 Turtle blocks, using one of the straight-line patchwork techniques on pages 7–16.
2. Sew 2 black buttons onto each block for eyes. Stitch buttons on with a bright-colored thread. (If you plan to machine quilt, you may prefer to leave this step until after the quilting has been completed.)
3. Trim the finished blocks to 9½" x 9½".

DELECTABLE MOUNTAINS BLOCKS

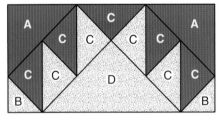

Whole Block
Make 21

Half Block
Make 6

1. From the black, cut:
 3 strips, each 4⅞" wide; crosscut the strips to make 24 squares, each 4⅞" x 4⅞". Cut each square in half *once* diagonally for a total of 48 half-square triangles (piece A).
 4 strips, each 5¼" wide; crosscut the strips to make 30 squares, each 5¼" x 5¼". Cut each square in half *twice* diagonally for a total of 120 quarter-square triangles (piece C); discard 3 triangles.
 Trim the unused part of the last 5¼" strip to 2⅞" wide; crosscut the strip to make 3 squares, each 2⅞" x 2⅞". Cut each square in half *once* diagonally for a total of 6 half-square triangles (piece B).
2. From the multicolored print, cut:
 2 strips, each 2⅞" wide; crosscut the strips to make 24 squares, each 2⅞" x 2⅞". Cut each square

in half *once* diagonally for a total of 48 half-square triangles (piece B).

3 strips, each 5¼" wide; crosscut the strips to make 24 squares, each 5¼" x 5¼". Cut each square in half *twice* diagonally for a total of 96 quarter-square triangles (piece C).

2 strips, each 9¼" wide; crosscut the strips to make 6 squares, each 9¼" x 9¼". Cut each square in half *twice* diagonally for a total of 24 quarter-square triangles (piece D); discard 3 triangles.

Trim the unused part of the last 9¼" strip to 4⅞" wide; crosscut the strip to make 3 squares, each 4⅞" x 4⅞". Cut each square in half *once* diagonally for a total of 6 half-square triangles (piece A).

3. Construct 21 Delectable Mountains blocks and 6 half blocks as shown.

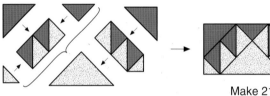

Make 21

Make 6

Quilt Top Assembly

1. From the black, cut:
 4 strips, each 3½" wide; crosscut the strips to make:
 8 pieces, each 3½" x 9½" (piece X)
 6 pieces, each 3½" x 12½" (piece Y)
 2 strips, each 2" wide; crosscut the strips to make:
 4 pieces, each 2" x 12½" (piece Z)
2. Sew a piece X to each Turtle block at the lower left leg as shown.

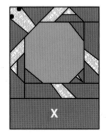

Make 8

[handwritten annotations at top: "92½ Finished 12½ 14 X 12½"]

3. Lay out the Turtle blocks and Y and Z pieces as shown. Sew the blocks and strips together to make 2 rows.

[handwritten: "1½ 9 3" ... "10½"]

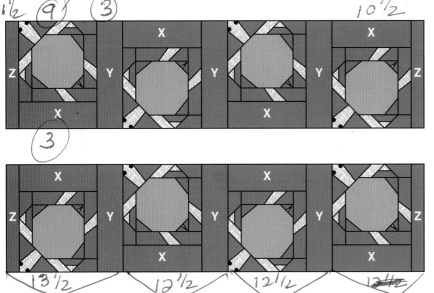

[handwritten: "3"]

[handwritten along bottom: "13½ 12½ 12½ 12½"]

4. Lay out the Delectable Mountains blocks and half blocks as shown, making 3 of each row. Join the blocks into rows.

Make 3

Make 3

5. Lay out the rows of Delectable Mountains and Turtle blocks as shown in the quilt diagram. Join the rows.

6. From the black, cut 6 strips, each 2½" wide; crosscut and join strips as required to make:

 2 pieces, each 2½" x 52½" (top and bottom inner border)

 2 pieces, each 2½" x 60½" (side inner border)

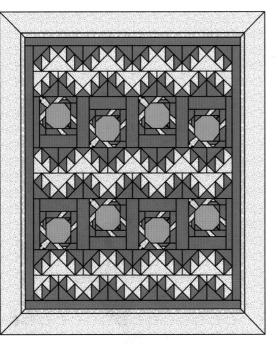

7. Join the longer strips to the sides of the quilt, then add the remaining strips to the top and bottom.

8. From the light green, cut 6 strips, each 1½" wide; crosscut and join strips as required to make:

 2 pieces, each 1½" x 56" (top and bottom center border)

 2 pieces, each 1½" x 68" (side center border)

9. From the multicolored print, cut 8 strips, each 5½" wide; crosscut and join strips as required to make:

 2 pieces, each 5½" x 66" (top and bottom outer border)

 2 pieces, each 5½" x 78" (side outer border)

10. Referring to the directions on page 23, join each of the longer center border strips to one of the longer outer border strips along the lengthwise edges, matching centers. Repeat with the shorter border strips. Sew the resulting border units to the quilt, mitering the corners (pages 23–24).

Quilt Finishing

1. Cut your backing fabric in half crosswise. Join the halves as described on page 25.

2. Layer the quilt top with batting and backing; baste.

3. Quilt in the design of your choice. *Suggested design:* Outline-quilt the turtles. Free-motion quilt in background. Quilt a pattern in the turtle shells. Outline-quilt the Delectable Mountains blocks and quilt zigzag lines inside print areas. Outline-quilt the center border. Quilt random straight lines in the outer border.

4. From the multicolored print, cut 7 strips, each 2½" wide. Bind the quilt, following the directions on page 26 and joining strips as required.

Turtle Quilt

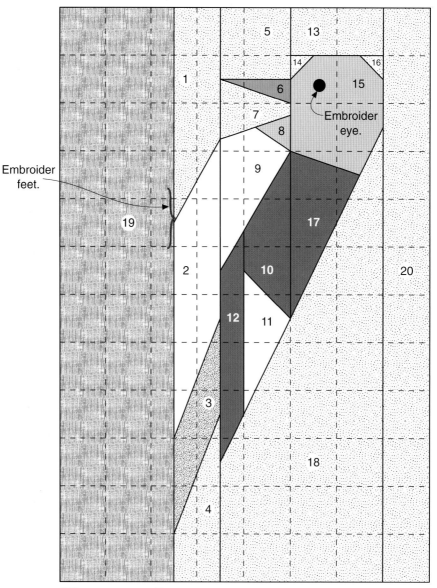

Embroider feet.

Embroider eye.

WOODPECKER BLOCK
Block size shown: 4" x 6" • 1 square = ½"

Color Key

Follow this color key if you wish to make the woodpecker in its natural coloration.

☐ Breast and wing patch (white)—2, 9, 11

▨ Tail (black and white)—3

▦ Beak (gray)—6

▨ Head and neck (red)—8, 15

■ Wing (black)—10, 12, 17

▨ Tree (brown)—19

▨ Background—1, 4, 5, 7, 13, 14, 16, 18, 20

Size Options

To enlarge from the grid (8 squares x 12 squares):

For an 8" x 12" block, 1 square = 1"

To enlarge by photocopying:
For an 8" x 12" block, enlarge by 200%.

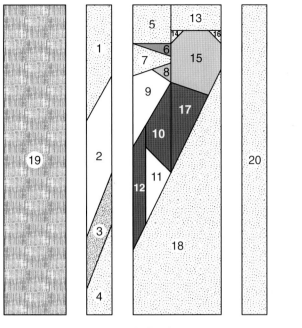

Major Block Sections

Piecing Order

1. 1 + 2 + 3 + 4

◆◆◆◆◆◆◆◆◆

2. 5 + 6
3. (5-6) + 7
4. 8 + 9
5. 10 + 11
6. (10-11) + 12
7. (5-7) + (8-9) + (10-12)
8. 14 + 15 + 16
9. 13 + (14-16) + 17
10. (5-12) + (13-17)
11. (5-17) + 18

◆◆◆◆◆◆◆◆

12. (1-4) + (5-18) + 19 + 20
Embroider eye and foot.

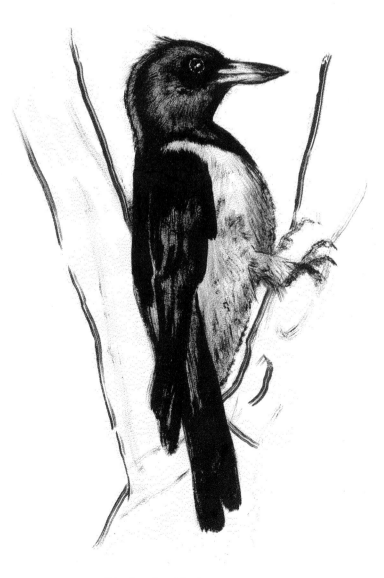

Woodpecker Block

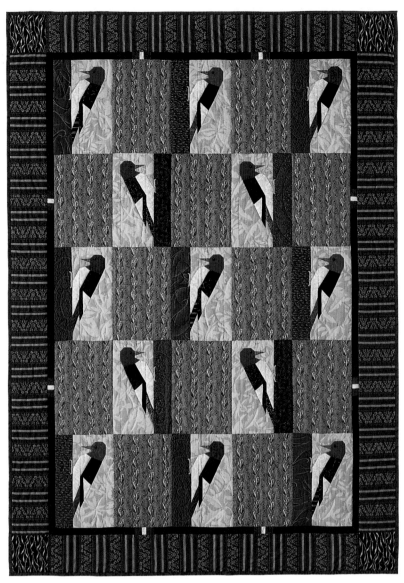

Woodpecker quilt, 52" x 72". Woodpeckers are busy pecking at their quilted trees. Hand quilted by Beth and Trevor Reid.

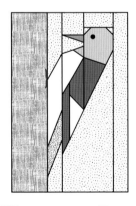

WOODPECKER BLOCK

Finished size: 8" x 12"
Enlarge the block on page 76 by 200%
or use a grid with 1" squares.

Materials: 44"-wide fabric

1¼ yds. light brown print for alternate blocks
1 yd. brown-and-red print for outer border
¾ yd. total of assorted red prints for bird heads, inner border, and binding
¾ yd. beige print for background
½ yd. total of assorted brown prints for tree trunks
½ yd. total of assorted black prints for bird wings and inner border
¼ yd. white print for bird breasts and inner border
¼ yd. brown print for corner squares
⅛ yd. black-and-white print for bird tails
Small piece of gray print for beaks
56" x 76" piece of batting
3¼ yds. backing fabric
Black and gray embroidery floss

Block Assembly

WOODPECKER BLOCKS

1. Cut and piece 13 Woodpecker blocks, using one of the straight-line patchwork techniques on pages 7–16. Make 9 regular blocks and 4 reverse blocks.
2. Using a chain stitch and 2 strands of embroidery floss, embroider eyes in black, and feet in gray (page 21).
3. Trim the finished blocks to 8½" x 12½".

Quilt Top Assembly

1. From the light brown, cut 12 rectangles, each 8½" x 12½" (alternate blocks).

2. Sew the Woodpecker blocks and the alternate blocks together into rows as shown. Referring to the quilt diagram, join the rows.

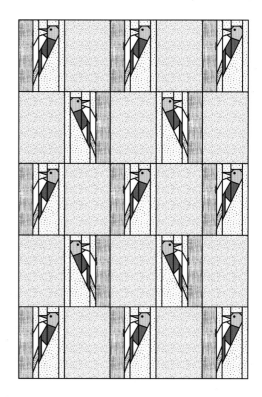

3. From one of the red prints, cut 2 pieces, each 1½" x 13".
4. From the white print, cut 1 piece, 1" x 13".
5. Join the strips along the 13" sides with the white strip in the center as shown. Crosscut to make 8 units, each 1½" wide.

1½"

6. From one of the black prints, cut 5 strips, each 1½" wide; crosscut the strips to make:
 4 pieces, each 1½" x 12¼"
 2 pieces, each 1½" x 14"
 4 pieces, each 1½" x 17¼"
 2 pieces, each 1½" x 22"

7. Join black strips and pieced units as shown, making 2 of each (inner border strips).

8. Join the long inner border strips to the sides of the quilt, then add the remaining border strips to the top and bottom of the quilt.

9. From the brown-and-red print, cut 5 strips, each 5½" wide; crosscut and join strips as required to make:
 2 pieces, each 5½" x 42½"
 2 pieces, each 5½" x 62½"

10. From the brown print for the corner squares, cut 1 strip, 5½" wide; crosscut the strip to make 4 squares, each 5½" x 5½".

11. Join the 62½" outer border strips to the sides of the quilt. Sew a corner square to each end of the remaining border strips, then add the resulting units to the top and bottom of the quilt.

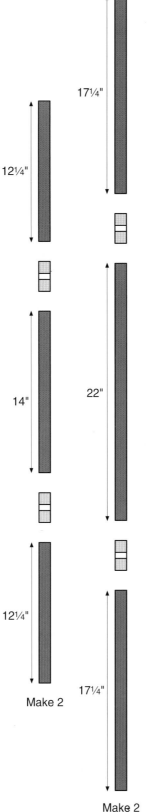

Quilt Finishing

1. Cut your backing fabric in half crosswise. Join the halves as described on page 25.

2. Layer the quilt top with batting and backing; baste.

3. Quilt in the design of your choice.
 Suggested design: Outline-quilt the woodpeckers. Free-motion quilt the backgrounds in the bird blocks. Quilt a pattern of bark in the tree trunks. Quilt vertical sinuous lines in the alternate blocks. Outline-quilt the inner border. Quilt straight lines in the outer border and squares in the corner squares.

4. From a red print, cut 7 strips, each 2½" wide. Bind the quilt, following the directions on page 26 and joining strips as required.

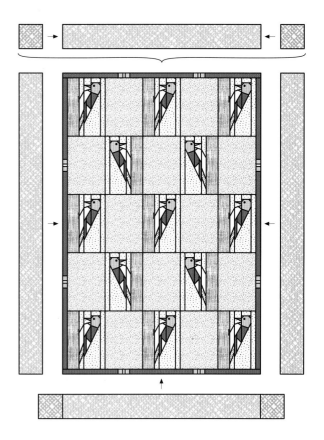

Miniature Birds

Foundation piecing is a great way to make small blocks accurately and easily. Simply sew fabric pieces to one side of a paper design by carefully following lines on the other side. This method can be applied to the Goldfinch (page 30) and the Chickadee (page 35) designs with delightful results.

Before you begin, note these general points:

1. Use larger rather than smaller pieces of fabric. Because this is a "sew and flip" technique (like Log Cabin, but using odd shapes), it can be difficult to accurately predict how a particular patch will flip into place after sewing. Avoid problems by using generous pieces of fabric. Only small amounts of fabric are involved anyway, so there won't be much waste.

2. Ignore grain lines. It is just too difficult to try and match up the grain with this method, but since it is very accurate, why worry?

3. All sewing is done on the wrong side of the paper; fabrics are attached to the right side of the paper.

4. The design will look messy as you go. Only at the end will the design appear clearly. Sew on the lines, and it will come out right.

FOUNDATION PIECING

1. Trace or photocopy the pattern. The thick lines outline sections of the block. Sections are also labeled by letters: A, B, C, and so on. Each piece in the block is numbered according to the piecing order. If you trace, be sure to transfer all letters and numbers.

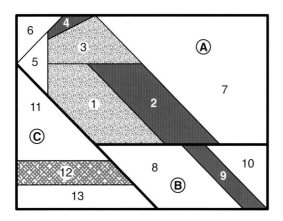

2. Cut around the outside edges of the block design and also along the thicker lines, so that the block is cut into sections. Mark the section letters on the wrong side of the paper; they will help you piece the sections together later.

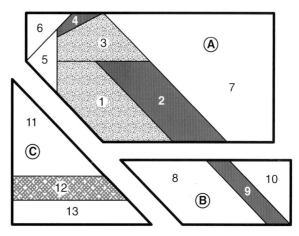

Transfer letter to wrong side of each section.

3. Unthread your machine and set it on a very short stitch length—a bit under 2. With the pattern right side up, stitch along the lines in each section. There are two reasons for this: first, it enables you to follow the design accurately from the wrong side; second, it weakens the paper, making it easier to remove later. The *right side* of the paper design has the printed lines, and the *wrong side* of the design has the lines of holes made by the machine.

4. Beginning with section A, cut a piece of fabric to cover piece 1. You do not have to cut out the fabric accurately—just cut a patch that will cover the shape required, plus at least ¼" all around for seam allowances. Pin the piece in place on the *right side* of the paper, with the fabric *right side up*. (This piece is like the center square of a Log Cabin block—it is the only piece you put right side up.)

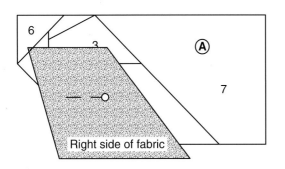

Right side of fabric

5. Cut out a second piece of fabric large enough to *generously* cover the shape of piece 2 plus seams. Lay it on top of the first piece of fabric, *right side down*. Position the piece so it will cover the shape of piece 2 *after* it is sewn and flipped over. Pin in place, being careful to place the pin away from where you will be stitching. (At this stage you may take out the pin holding piece 1 in place.)

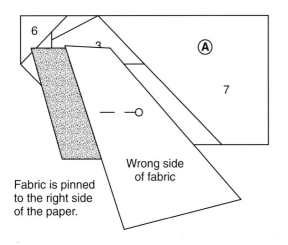

Fabric is pinned to the right side of the paper.

Wrong side of fabric

6. Thread the machine and set the stitch length on 2 (small stitch). Stitch along the line on the *wrong side* of the paper design, starting ¼" before the end of the line and ending ¼" after the end of the line as shown. Snip off the threads, leaving ¼" tails. Trim the seam allowance to ¼".

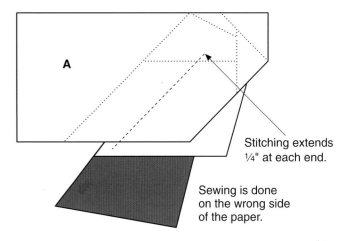

Stitching extends ¼" at each end.

Sewing is done on the wrong side of the paper.

On the right side, flip the fabric over into its correct place and press.

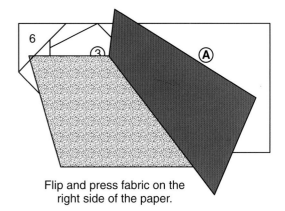

Flip and press fabric on the right side of the paper.

7. Following the piecing order, continue cutting and sewing patches in this manner until the section is complete. It will look messy and have funny edges—*leave these for now.*

8. Complete all sections of the design in the same way, adding pieces in order.
9. Lay out the block so that each section is in its correct place. You will join the sections in alphabetical order: A + B, (A-B) + C, and so on.
10. Pick up the first two sections to be sewn. With a rotary cutter and small ruler, trim the relevant outside edges of each section to an accurate ¼" beyond the paper pattern. Trim *only* the sections you are about to sew. Leave the paper pattern on.

11. The sections are pieced together using regular (not foundation) piecing methods. With right sides together, line up the two sections, matching the corners of the paper patterns as well as the cut edges. Anchor the sections together with pins pushed in vertically at the corners of the paper sections. Stitch along the edge of the paper, keeping the cut edges of the fabric even as you sew. Press.
12. Continue to trim and sew sections together until the block is complete.
13. Trim the outside edges of the block so that it is exactly the desired finished size plus ¼" all around.
14. Gently remove the paper. A seam ripper or a pin can help pull out any stubborn bits.
15. Add strips to make the block square. It is easiest to cut these strips in a generous width, sew them to the block, and then trim the block to the exact finished size plus ¼"-wide seam allowances.
16. Add borders or use blocks in small quilts as desired.
17. Add details with embroidery, beads, permanent ink pen, or appliqué. Add small appliqué shapes simply with fusible web, using a few machine or hand stitches to secure the shapes.

Trim to ¼".

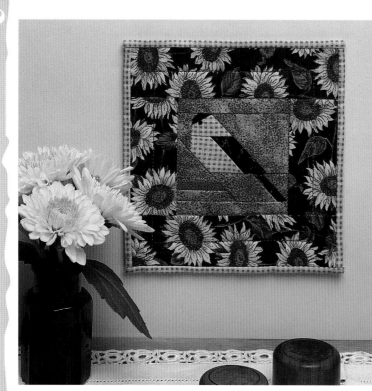

Miniature Goldfinch: 5¾" x 5¾"

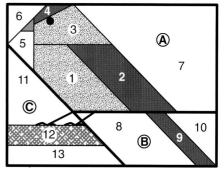

Finished size: 3" x 2¼"
(3" x 3" with strips added to
top and bottom)
Full-size pattern on page 86.

Materials

Scraps of fabric in yellow (Pieces 1, 3) and
 black (Pieces 2, 4, 9) for bird
Scraps of fabric for perch, background,
 borders, and binding
Scrap of very thin batting or flannel
Scrap of backing fabric
Small black bead for eye
Orange and brown embroidery floss

Major Block Sections

Block Assembly

1. Trace or photocopy the block on page 86.
2. Construct the block, following the general in-
 structions on pages 81–82. Trim the block to
 3½" x 2¾".
3. Cut 2 strips of background fabric, each 1½" x 4".
 Add to top and bottom of block. Trim the block
 to exactly 3½" x 3½".
4. Add borders as desired.
5. Using 2 strands of embroidery floss, embroider
 beak in orange, and legs in brown (page 21). Sew
 on a small black bead for eye.
6. Layer block, batting, and backing; quilt as
 desired.
7. Cut binding fabric into 1¾"-wide strips. Bind the
 block, following the directions on page 26.

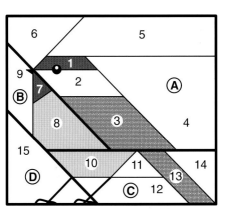

Finished size: 3" x 2⅝"
(3" x 3" with strips added to
top and bottom)
Full-size pattern on page 86.

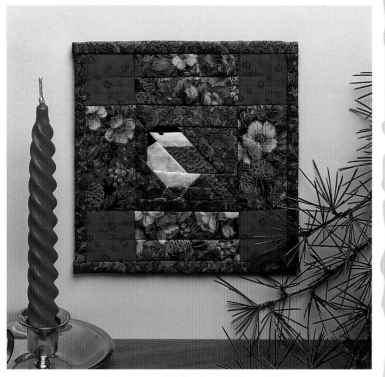

Miniature Chickadee: 6¼" x 6¼"

Materials

Scraps of fabric in cream or white (pieces 2, 8, 10), black (pieces 1, 7), and gray or brown (pieces 3, 13) for bird

Scraps of fabric for background, borders, and binding

Scrap of very thin batting or flannel

Scrap of backing fabric

Black and gray embroidery floss

Block Assembly

1. Trace or photocopy the block on page 86.
2. Construct the block, following the general instructions on pages 81–82. Trim the block to 3½" x 2⅞".
3. Cut a 1" x 4" strip of background fabric. Add to the bottom of the block. Trim the block to exactly 3½" x 3½".
4. Add borders as desired.
5. Using 2 strands of embroidery floss, embroider beak and eye in black, and legs in gray (page 21).
6. Layer block, batting, and backing; quilt as desired.
7. Cut binding fabric into 1¾"-wide strips. Bind the block, following the directions on page 26.

Major Block Sections

FULL-SIZE PATTERNS FOR MINIATURE BIRDS

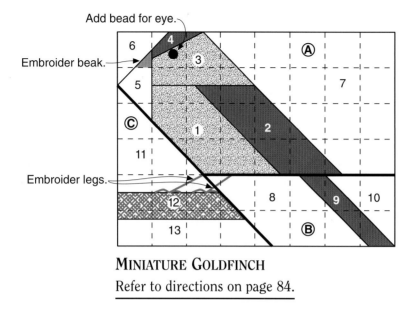

MINIATURE GOLDFINCH
Refer to directions on page 84.

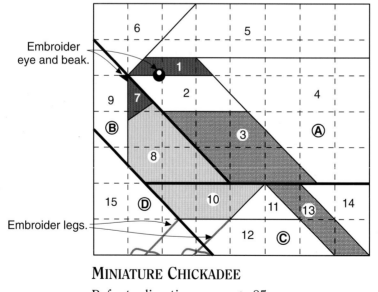

MINIATURE CHICKADEE
Refer to directions on page 85.

Designing Quilts with Animal Blocks

While I hope you enjoy the quilts I created using the animal blocks, I hope even more that you will go on to use the animal designs to create your own quilts. Following are some thoughts you may find useful as you design original quilts.

CREATING SPACE

The animals look best if they have some space around them. Some of the designs have space around the animal within the block, but I often use the edges of the block as part of the design, and these animals need extra space around them to create a figure/ground relationship (which just means that you can see the animal against the background). Though color choices play a part here (see "Choosing Colors and Fabrics" on page 6), the way you use the block is also important. An example of a design where the edges are part of the design is the Chipmunk block (page 45).

Approaches to Creating Space

1. Create space around the animal by attaching strips around the block and making it larger. When planning a quilt, use this larger size as your block size. For example, if you make the Chipmunk block in the 9" x 9" size, you could add 1½" strips to make the block 12" x 12".

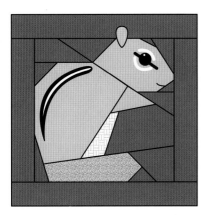

NOTE: You can also add strips if you plan to combine several different animal blocks in one quilt. Make the animal blocks 9" or 10" square, then add strips to make them all 12" square, for example.

2. Combine animal blocks with blocks that use the same background fabric. For example, see the Deer and Turtle quilts (pages 42 and 73).

3. Combine animal blocks with blocks that have space at their edges, again using the same background fabric in both blocks. For example, the combination of the Chimneys and Cornerstones and Goldfinch blocks creates a nice space for the bird to sit in (page 32). Other useful blocks include Puss in the Corner and variations of the Irish Chain.

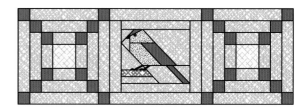

UNDERSTANDING SYMMETRY

As most of the blocks in this book are asymmetrical, it is important to understand symmetry. Symmetry occurs when two halves of something are the same and, thus, are a mirror image of each other. To test for symmetry, ask yourself, "If I draw a line through the center of the design, are the two halves the same?" The line could be drawn vertically, horizontally, or diagonally. Some designs are symmetrical in all directions and can be divided horizontally, vertically, and diagonally. A few block designs illustrate the point:

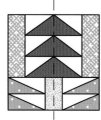

Tall Pine Tree
(vertical division)

Fish
(horizontal division)

Flower Basket
(diagonal division)

Sawtooth Star
(multiple divisions)

The animal blocks are mostly asymmetrical, which means there is no line dividing two mirror-image halves. The only exception is the Turtle block, which is symmetrical on the diagonal.

Asymmetrical Design Symmetrical Design

You need to understand symmetry because of what happens when blocks are repeated. So read on . . .

USING REPETITION

Pattern is created through repetition, a very important tool in quilt design. Repetition is particularly interesting when designs are asymmetrical, because both the designs and the spaces between them create all sorts of patterns. There are just three ways of repeating something without changing it. I call them the three Rs of repetition: repeating, reversing, and rotating.

1. **Repeating.** The block can be repeated in horizontal rows, vertical rows, across the diagonal, in a half-drop pattern, or randomly.

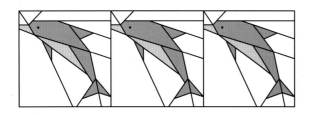

Straight repetition is the basis of many of the quilts in this book. For example, in the Puffin quilt (page 68), the birds are repeated in horizontal and vertical rows. In the Goldfinch quilt (page 32) and Deer quilt (page 42), the blocks are repeated on the diagonal. In the Dolphin quilt (page 58), there is a half drop between two of the repeating blocks.

2. **Reversing.** This involves making a mirror image of the block.

Reversing the animal design is the basis of the Chickadee quilt (page 37) and the Chipmunk quilt (page 47).

3. **Rotating.** The block is kept the same but is rotated around an axis. The point of the axis can vary, giving different effects.

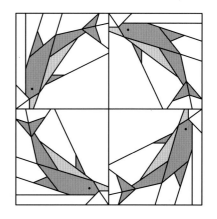

Rotation can be seen in the Turtle quilt (page 73) and the Dolphin quilt (page 58).

COMBINING ANIMAL BLOCKS WITH OTHER PATCHWORK

A great way to make quilts is to combine animal designs with other patchwork designs. Here are some ideas:

- Add borders, which can be as simple as strips of fabric or as complex as you like, including pieced patterns and multiple borders. A block with borders makes a quick and easy wall hanging (page 23). I like the interest created by corner squares, which is why you see them in many of my quilts.
- Make a diamond space around the animal by adding quarter-square triangles around the edges. To make the block square again, add half-square triangles to the corners. The math is easy, because in each case you cut squares that equal the finished size of the animal block plus the appropriate seam allowances, which depend on whether the triangles are quarter or half squares (page 17). For example, for a 9"

block, you would cut a 10¼" square for the quarter-square triangles and two 9⅞" squares for the half-square triangles.

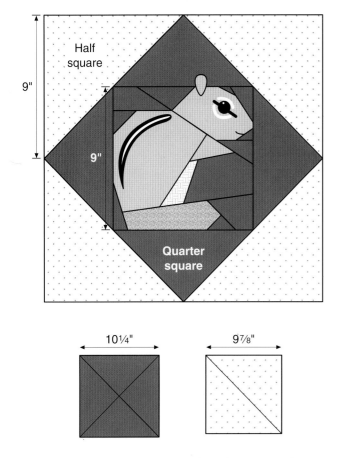

Half square

9"

9"

Quarter square

10¼"

9⅞"

- Repeat the animal block with sashing strips between blocks. The Puffin quilt (page 68) was made this way, although the sashing is pieced.
- Repeat the animal block with alternating pieced or plain blocks. The Woodpecker quilt (page 78) is an example of using a print as the alternate block. The Goldfinch quilt (page 32) shows a pieced alternate block. If you plan to combine a pieced block with an animal block, make sure the blocks go together well in terms of both design and construction. You don't want an alternate block that overwhelms the animal block, nor do you want one that is a difficult size to

sew—combining a 9" animal block with a 10" pieced block is a challenge. If this latter situation does arise, enlarge the animal block through photocopying or by adding strips.

- Add patchwork borders. An example of this is the Ninepatch border in the Chickadee quilt (page 37).
- Combine several animal blocks. Remember to give each animal its own space as discussed earlier. Some kind of linking patchwork, such as a Puss in the Corner block, may help unify the blocks.
- Use the designs pictorially, such as the sunset scene in the Flying Geese quilt (page 63).
- Base the rest of the quilt on the size of your animal block. The Chipmunk quilt (page 47) was designed on this principle: the 9" chipmunk blocks are combined with 4½" Maple Leaf blocks, 1½"-wide sashing, and 3" half-square triangles. Because 4½, 3, and 1½ are one-half, one-third, and one-sixth of 9, respectively, the parts are easy to combine. See the excellent book *One-of-a-Kind Quilts* by Judy Hopkins (That Patchwork Place, Inc.) for more ideas.
- When using blocks of the small birds, such as the Chickadee (page 35), try to maintain a sense of the smallness of the bird. If you need to include them with other larger blocks, either add wide strips around the birds to make the block larger, or combine two birds into one block, adding extra strips to bring the block up to size as shown below.

Two 6" x 6" bird blocks
combined with added strips
to make a 12" x 12" block.

The important principles for metric conversion are:

1. Do not mix the two measuring systems together. Use one or the other.

2. Replace ¼"-wide seam allowances with 0.75cm seam allowances.

3. To rotary cut squares, rectangles, and strips that include 0.75cm seam allowances, add 1.5cm to the finished measurements.

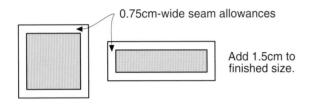

0.75cm-wide seam allowances

Add 1.5cm to finished size.

4. To rotary cut *half-square triangles* that include 0.75cm seam allowances, cut a square that is 2.5cm larger than the short sides of the finished triangle. Cut the square once diagonally to yield 2 triangles.

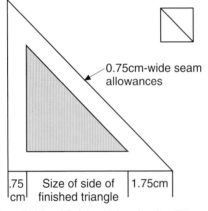

0.75cm-wide seam allowances

.75 cm | Size of side of finished triangle | 1.75cm

= size of side of finished triangle plus 2.5cm

5. To rotary cut *quarter-square triangles* that include 0.75cm seam allowances, cut a square that is 3.5cm larger than the long side of the finished triangle. Cut the square twice diagonally to yield 4 triangles.

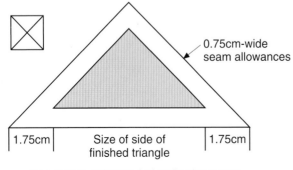

0.75cm-wide seam allowances

1.75cm | Size of side of finished triangle | 1.75cm

= size of side of finished triangle plus 3.5cm

TABLE OF USEFUL METRIC EQUIVALENTS FOR PATCHWORK

NOTE: This table does not give exact equivalents; the numbers have been rounded up or down to the nearest useful metric equivalent. When two metric measurements are given, choose the most convenient size.

¼"	= 0.75cm	
½"	= 1cm	
	or 1.5cm	*when you are adding two 0.75cm seam allowances together*
¾"	= 2cm	
1"	= 2.5cm	
1¼"	= 3cm	
1½"	= 4cm	
2"	= 5cm	
2½"	= 6cm	
3"	= 8cm	
4"	= 10cm	
5"	= 12cm	
6"	= 15cm	*(for Ninepatch blocks)*
	or 16cm	*(for Four Patch blocks)*
8"	= 20cm	
9" (¼ yd.)	= 24cm	
10"	= 24cm	*(for Four Patch blocks)*
	or 25cm	*(for five-patch blocks)*
12"	= 30cm	*(for Ninepatch blocks)*
	or 32cm	*(for Four Patch blocks)*
14"	= 36cm	*(for Four Patch blocks)*
	or 35cm	*(for seven-patch blocks)*
15"	= 39cm	*(for Ninepatch blocks)*
	or 40cm	*(for five-patch blocks)*
16"	= 40cm	
18" (½ yd.)	= 48cm	
20"	= 50cm	
36" (1 yd.)	= 90cm	
40"	= 100cm (1m)	

GOLDFINCH

Goldfinch block: 16cm x 16cm, 1 square = 2cm
Add 2cm-wide strips all around to make block 20cm x 20cm.
Chimneys and Cornerstones block: 20cm x 20cm
Inner border: 2.5cm wide
Outer border: 15cm wide

CHICKADEE

Chickadee block: 16cm x 16cm, 1 square = 2cm
Quilt center: 80cm x 80cm
Inner border: 4cm wide with 4cm corner squares, 8cm quarter-square triangles, and 4cm half-square triangles
Outer border: 16cm wide with 16cm quarter-square triangles
Ninepatch blocks: 12cm x 12cm, trimmed to 11.5cm x 11.5cm finished

CHIPMUNK

Chipmunk block: 24cm x 24cm, 1 square = 2cm
Maple Leaf block: 12cm x 12cm
Sashing and inner border: 4cm wide
Outer border: 8cm wide with 8cm half-square triangles

DEER

Deer block: 30cm x 30cm, 1 square = 3cm
Tree block: 30cm x 15cm
Inner border: 2.5cm wide
Outer border: 15cm wide

DOLPHIN

Dolphin block: 30cm x 30cm, 1 square = 2.5cm
Pieced squares: 15cm x 15cm with 15cm half-square triangles

FLYING GEESE

Flying Geese blocks: 30cm x 30cm, 1 square = 3cm
Pieced blocks: 30cm x 30cm (A blocks), 30cm x 15cm (B blocks), 15cm x 15cm (C blocks)
Inner border: 1cm wide (**Note:** Trim center of quilt by 1cm before adding the inner border.)

LOON

Loon block: 32cm x 32cm, 1 square = 4cm
Reed block: 32cm x 32cm
Inner border: 2.5cm wide
Outer border: 15cm wide

PUFFIN

Puffin block: 24cm x 24cm, 1 square = 3cm
Add 3cm-wide strips all around to make block 30cm x 30cm.
Squares in sashing strips: 6cm x 6cm
Outer border: 12cm wide

TURTLE

Turtle block: 24cm x 24cm, 1 square = 2cm
Setting pieces: 24cm x 6cm (X), 30cm x 6cm (Y)
Delectable Mountains block: 30cm x 15cm; half block, 15cm x 15cm
First border: 5cm wide
Second border: 2.5cm wide
Third border: 15cm wide

WOODPECKER

Woodpecker block: 20cm x 30cm, 1 square = 2.5cm
Alternate block: 20cm x 30cm
Inner border: 2.5cm wide
Outer border: 12cm wide

Meet the Author

Margaret Rolfe, an Australian quiltmaker, has had a lifelong interest in patchwork and quilting. She was particularly inspired to make quilting her own craft after living in the United States for several months in 1975. At that time, the American Bicentennial was approaching, and quilting was about to be discovered by American women as an exciting craft with a rich and wonderful past and a great creative future. After returning to Australia, Margaret combined the knowledge she had gleaned in the United States with a lot of learning by trial and error to make her own quilts.

During the 1980s, Margaret began to create original quilt designs. Her first were quilts of Australian wild flowers and wildlife. She found pieced blocks most intriguing, and her experimentation led to her unique approach to patchwork design and sewing. Her straight-line patchwork technique, as featured in this book, is the result.

Margaret's designs have been published in a series of books, including *Australian Patchwork Designs, Quilt a Koala,* and *Patchwork Quilts to Make for Children.* Her interest in history is reflected in her book *Patchwork Quilts in Australia.*

Go Wild with Quilts, her first book of pieced patterns for North American wildlife, was a result of Margaret's five-year stay in Canada in the late 1960s, as well as many trips to the United States and Canada since then. The success of this book and Margaret's continuing creation of new animal and bird designs has led to this second book, *Go Wild with Quilts—Again!*

Margaret's quilting career is enthusiastically supported by her scientist husband, Barry, and her three grown-up children, Bernard, Phil, and Melinda. Phil, an artist, has done illustrations for many of her books, and he has continued in this book by contributing the delightful drawings of the animals and birds.

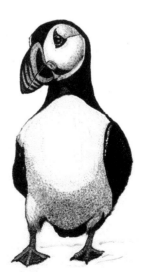